Let's MANGA 漫画

BODIES & EMOTIONS

TADASHI OZAWA

DMP™
Digital Manga Publishing

DIGITAL MANGA PUBLISHING
Los Angeles

Illustration: Tadashi Ozawa
Composition: Ken Sasahara
Translation: Matthew Johnson
Editing: Andy Grossberg
Print Production Manager: Fred Lui
Production Assistant: Eric Rosenberger
English Edition Layout/Production: John Ott
Publisher: Hikaru Sasahara

LET'S DRAW MANGA
BODIES AND EMOTIONS

English Edition Published by
DIGITAL MANGA PUBLISHING
1487 West 178th Street, Ste.300
Gardena, CA 90248
tel: (310)817-8010
fax: (310)928-8018

ISBN: 1-56970-938-6
Library of Congress Control Number 2005931158
First Edition: September 2005
10 9 8 7 6 5 4 3 2

Printed in China

TABLE OF CONTENTS

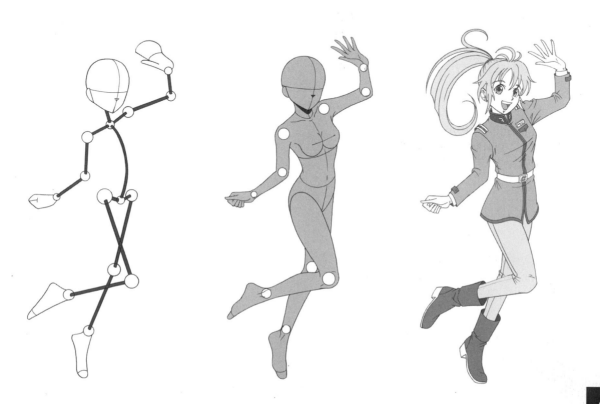

The Goal of This Book
Japanese anime and manga are popular throughout the world.

I was talking to a student in Los Angeles once who commented with frustration that it must take Japanese DNA to recreate the unique style and character design seen in Japanese anime and manga. Other people have said that no one but the Japanese can draw in the manga style…

This is certainly not the case.

If you truly have the desire to draw and commit to learning the secrets and techniques employed by artists, it does not matter what part of the world you are from.

This book was written to provide you with the foundation for drawing characters in the anime/manga style.

As you draw using the lessons presented in this book, try to gain an understanding of what the Japanese animators and cartoonists are thinking throughout the process. I have even included tips that were given to me by my superiors when I worked at a Japanese animation company.

It is thanks to these lessons that I was able to obtain work in this industry and currently support myself as a professional. If you master the material written in this book, you will have taken the first step to what I believe will be an incredible journey in illustration.

First...
Let's Try
Drawing

What Makes a Good Sketch?

It is often said that you have to be able to sketch well to draw characters. With manga and anime, you learn to draw by sketching plaster figures over and over just as you would in art schools. As time goes by, the teacher would stop giving direct instruction, and you would be expected to learn from your mistakes.

Still, there is something more important for animators and manga artists to be good at than drawing plaster figures. Just take a second and think about it. Some manga have characters that are 3 heads tall, but no such people exist in real life. Still, just because a 7-8 head-to-body ratio is the normal proportion for a human, nobody would look at a sketch of this 3 head tall character and say that it is strange.

That is because everybody knows that the sketch is in the manga style. Even so, you can determine whether you like or dislike this character just by looking at it. How can you do this? The character is

fictional and doesn't exist. How do you determine what is good or bad? Who decides? It all comes down to the innate sense of balance that we all have.

In Japan, someone performed the following test. A baby who still could not speak was shown his mother's face in a number of different ways, to determine if the baby would cry or not. First, he was shown his mother wearing a beard. Second, he was shown his mother with a third eye. Third, he was shown his mother with only one eye.

Which one do you think elicited the most crying?

The correct answer is #3. Human instinct expects the face to be arranged in the proper order. The second most upsetting image was #2. Although the sight of two eyes in the correct place was somewhat reassuring, the extra eye was still unnerving. However, the image of his mother with a beard did not upset the baby at all.

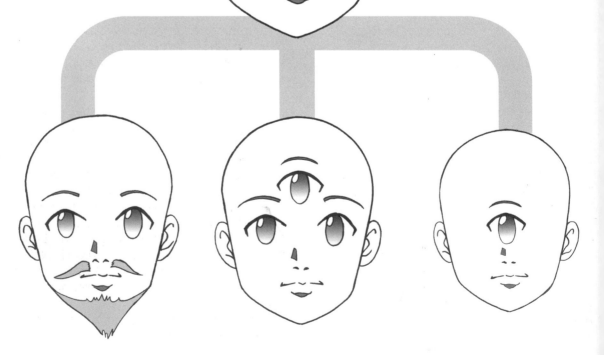

Ca

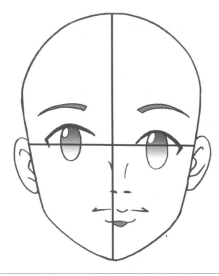
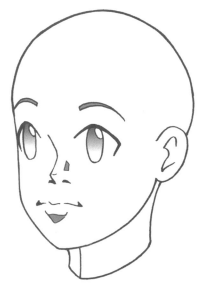
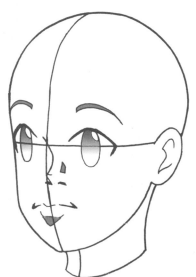

On the other hand, the baby will also cry if there are two eyes but they are not positioned properly. You can apply a similar test to see if your sketches are good enough. Even in the case of the fictional 3 head tall character, if the balance is off, the drawing is "bad".

The first step to skilled character design is balance. For the animator or manga artist, sketching a plaster figure is the test to see whether they can see this balance or not. The line between being a good or poor artist is determined before even a single line is drawn. If you can't see the correct balance of objects, you will not be able to draw well. If you can pick up the balance, then you will be drawing skillfully in no time. If you can't set up a plaster figure in your own room to practice, you can come very close to achieving the same effect by copying someone else's drawing.

Animators and cartoonists have been copying others since childhood. Hasn't everybody at one time tried to copy the drawings in a manga as they read it?

Isn't this just imitation...?

When I say "copy", I mean that you draw the original as you see it without changing it even a bit. Those people who went on to become pros would have looked closely at every last detail of the end product and determined what came out different. Practicing this way allowed them to improve.

In other words, they "developed an eye" for looking closely at drawings. People who are good at drawing say that you should draw exactly what you see. Those who are not good say they can't draw because they don't have the technique. Yet in order to acquire this technique, you first have to develop an eye for it.

Drawing Square Boxes Will Improve Your Technique (1)

Observe the varying levels of detail in the pictures below. One condition for being able to draw is to look at objects three-dimensionally. Put simply, it is a question of whether or not you can draw a square box. Anime and manga are limited to two-dimensional planes. However, the professional artist manipulates the two dimensional plane to give the illusion of a three-dimensional world.

No matter how cool your character looks, without the ability to create the illusion of three dimensions, your abilities will not improve.

Think back to your childhood and your favorite personal drawings from that time.

When you drew a car, it was probably a simple, flat drawing with two tires from the perspective of looking straight at the car from the side. As you improved, you probably started drawing the car from different angles. Even though the change was mostly unconscious, your drawings became more skillfully rendered as you learned how to capture space. This is the essence of improving your skills, and the basic technique for creating a more complicated drawing. As illustrated below, removing the minor details from a car or tank leaves you with simple square boxes.

When a skille
unskilled one
same object,
the image in

You will al
world the way
see it. It is the
you enjoy you
or manga. It c
have an intere
characters an
are skillfully re
no doubt like t
because you t
characters and
are cool or cut
take a look at
pictures are dr

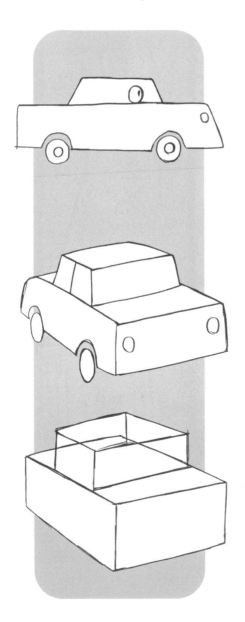

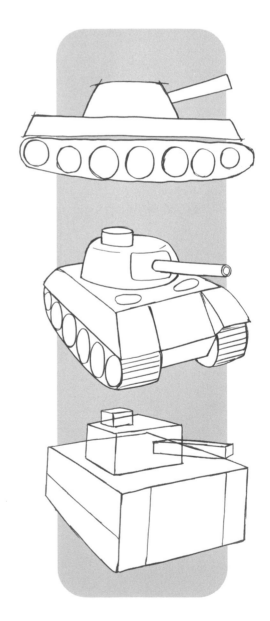

Even the Pros Start With Square Boxes

Whether it is somebody drawing their first illustration, or a new graduate from art school, or a new intern at an illustration company, which do you think they draw better: characters or machines? (I am certain you know the answer because you are probably better at machines as well).

In my experience, those who can draw machines skillfully can draw characters skillfully as well. Conversely, those who cannot draw machines do not become good at drawing characters either. The reason is that they have not properly learned to capture space.

When attempting to depict action, it is necessary to be very familiar with human anatomy and use that knowledge when making use of various angles in three-dimensional space. If you can draw the boxes that make up the initial image of a machine and keep adding detail to them, you will be able to capture space more accurately. Machines are a great way to start, as they do not contort in as complex a fashion as the human model does, and they do not show emotions such as laughter or anger.

If you just start with the squares and boxes and then add the details, the drawing will eventually start to look something like a machine.

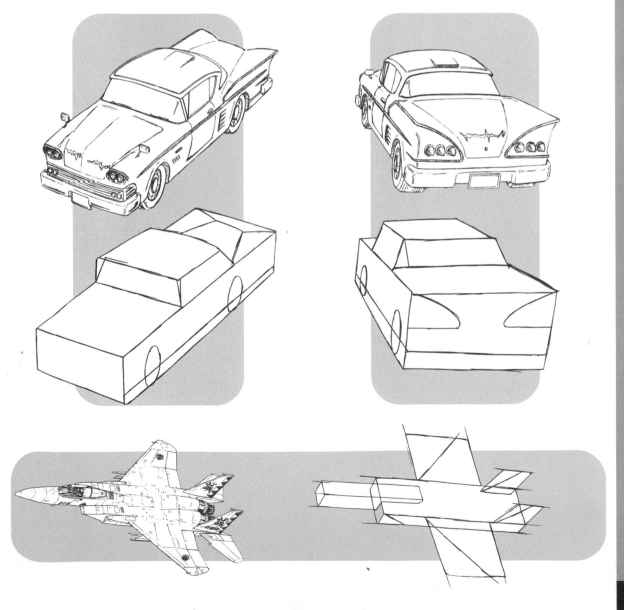

No Car is Simply Called "Car"

While machines are usually said to be easier to draw than characters, as you go along, you are sure to find that machines can also be quite complicated. When working on video game design, I need to pay close attention to the details of the machines as well as the characters.

A person with more experience once taught me "there is no car simply called 'car'. You should refer to them as a '32 Ford or '55 Chevy. Think of them in the same way you draw a tank that the viewer will recognize as a WWII German Tiger 1 tank, or a Spitfire fighter plane used by the English."

Being cognizant of the differences between

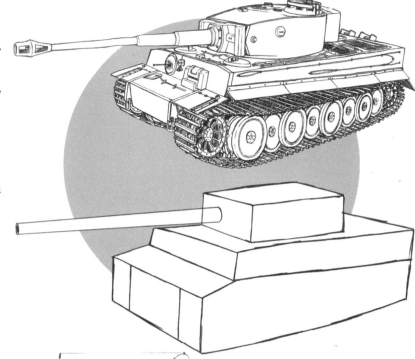

machines from the past will translate to success as you design fictional objects of the future. Even space-ships or robots will have companies that build them and engineers that design them. You must think of these as well when you design these objects.

When drawing a human character, it is just as important to think about what clothes they wear, or the shape of their face. The thing that is great about the people who design machines is that they can "see" and draw the object without looking at any photos or drawings. It is the same for characters. Professional manga artists and animators can "see" the characters and draw them from memory.

Drawing Square Boxes Will Improve Your Technique (2)

The drawings below depict boxes in varying stages of three-dimensional design. Particularly in anime and manga, it is necessary to adjust perspective to the scene in mind. You've taken photos with a camera before, right? Then you know that depending on the lens and zoom, the objects in your picture will appear to be different sizes and the perspective will be different. Try practicing drawing these boxes without using a ruler.

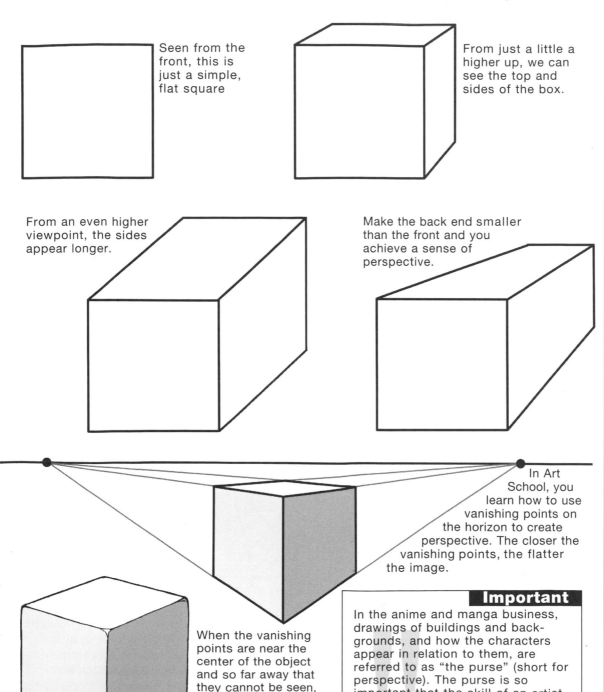

Seen from the front, this is just a simple, flat square

From just a little a higher up, we can see the top and sides of the box.

From an even higher viewpoint, the sides appear longer.

Make the back end smaller than the front and you achieve a sense of perspective.

In Art School, you learn how to use vanishing points on the horizon to create perspective. The closer the vanishing points, the flatter the image.

When the vanishing points are near the center of the object and so far away that they cannot be seen, the lines of the object will be very close to parallel and will look like this.

Important

In the anime and manga business, drawings of buildings and backgrounds, and how the characters appear in relation to them, are referred to as "the purse" (short for perspective). The purse is so important that the skill of an artist is determined not by how well they draw characters, but whether they can proficiently draw the purse or not.

Using Square Boxes for Figures (1)

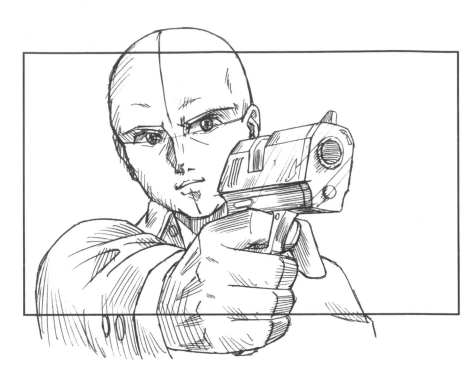

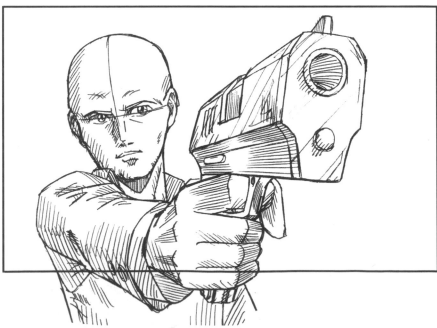

What makes manga, anime, and movies so interesting is that the stories allow you to create all different types of compositions. If you use various shapes and sizes of boxes throughout your work, it will be more interesting to the viewer and your skills will improve.

The drawings above show the same shot, but one is a wide shot, and one is tight. Look at the difference in the purse of the pistol. Just as with the boxes, different angles not only present you with a different view, but a different feel as well.

Using Square Boxes for Figures (2)

Square boxes aren't just for drawing machines and handguns; they are necessary for proper depiction of the human form as well. Picture the three-dimensional human body and think of it in terms of boxes. Before you're able to draw a pretty girl, you'll need to be able to see the entire body in three dimensions. This is also how they do it in art schools and it serves the same purpose as the plaster figures. Once you become accustomed to drawing, there will be no need to draw the boxes, but you should always keep them in mind to make certain you think in three dimensions.

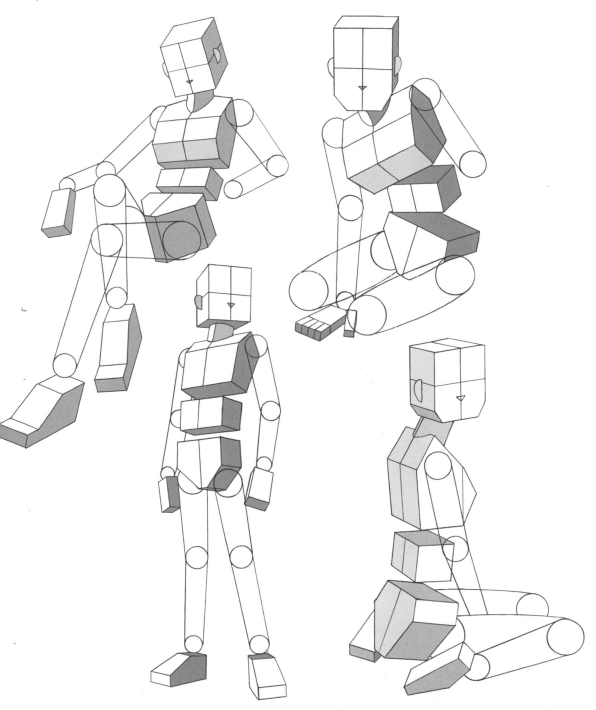

What is the Thought Process in Your Drawing?

Drawing nothing but square boxes isn't very interesting, so let me introduce the methods and thought processes I use for creating pictures. I rarely draw square boxes anymore, but I am always thinking in those terms in my head. If I didn't, I couldn't create a three-dimensional character.

While in the end the details of each segment and the drawing technique are important, please remember that you start by making the object you want to draw a three-dimensional figure.

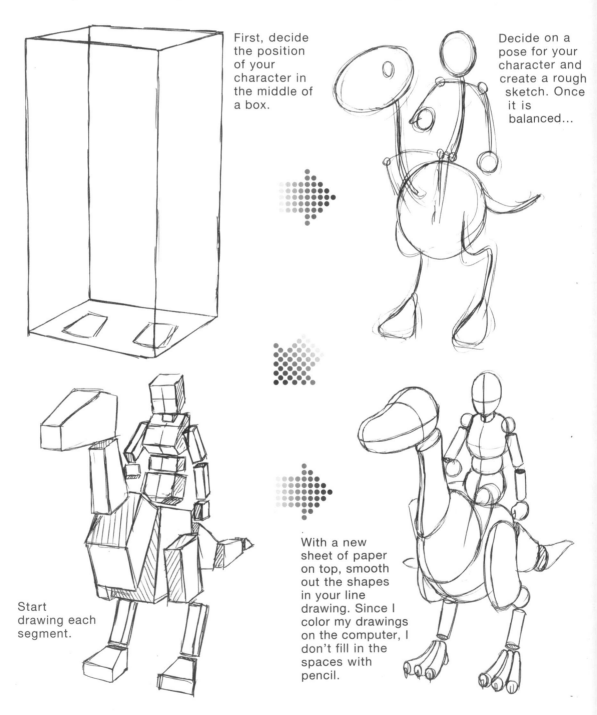

First, decide the position of your character in the middle of a box.

Decide on a pose for your character and create a rough sketch. Once it is balanced...

Start drawing each segment.

With a new sheet of paper on top, smooth out the shapes in your line drawing. Since I color my drawings on the computer, I don't fill in the spaces with pencil.

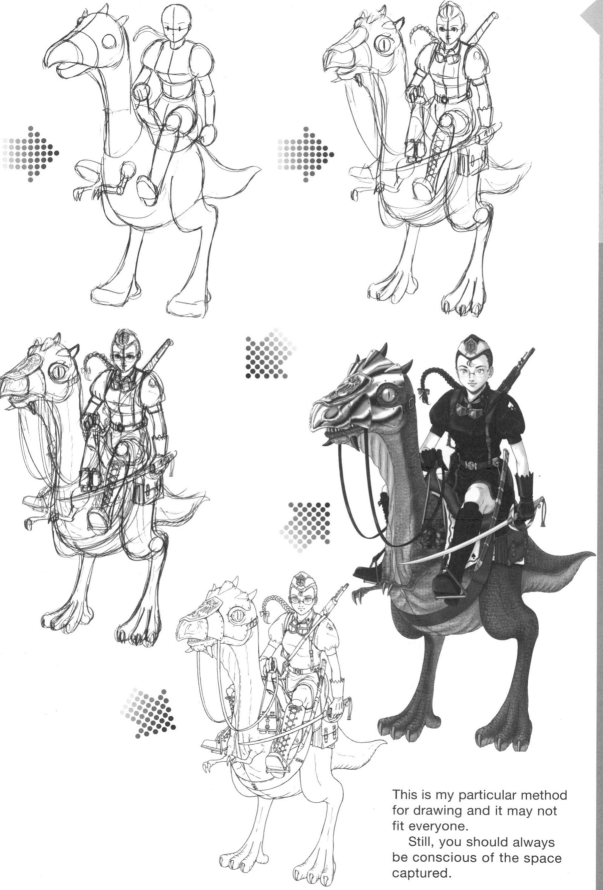

This is my particular method for drawing and it may not fit everyone.

Still, you should always be conscious of the space captured.

Proportions

When you reach the point where you can confidently draw space, the next concern is balance. For characters, you must first decide how to relate the head to the body.

Changing the scale is just the beginning. If there are 10 different people drawing a picture, there will be 10 different styles of drawing. If you are drawing alone, for your own enjoyment, balance is not that much a concern, but what if you want to become a professional, or show off your drawings to others?

Even if you are just drawing for yourself, I'm sure there have been times when things just don't look right. This is a sign that there is a flaw somewhere in your process. Could

it be your sketch? Your design? If you still can't find it, it's likely a problem with balance.

Drawings in the manga style have their own unique balance. Though some of it boils down to personal taste, there is a way to make these drawings look better.

For example, the size of the hands and feet are different on the two characters below. I prefer the one with the larger hands and feet, but how about you?

Also, take a look at the student's work below. Making slight changes in the size of the head and the thickness of the fingers has an extremely different result.

How will your drawing look?

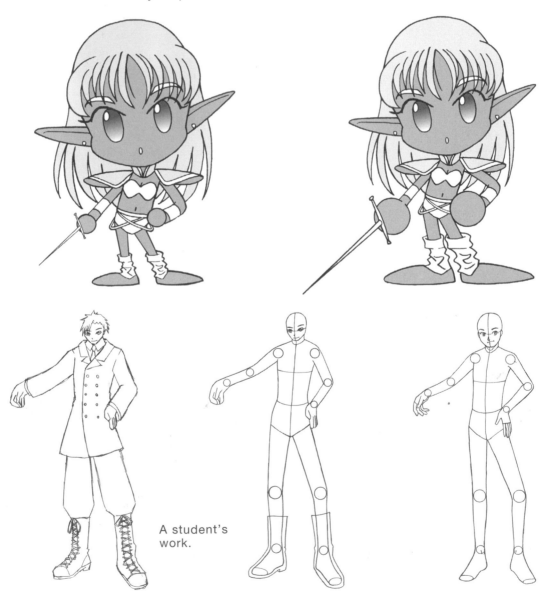

A student's work.

Let's look at the work of another student. Before judging whether the picture is good or bad, can you see what areas require improvement?

I modified the thickness and inclination of the upper body and repositioned the feet. If you are only told that the sketch looks funny, or that you are no good at drawing without concrete criticism, it is difficult to tell what is wrong. It is a safe bet, though, to assume that the problem usually has to do with balance.

A student's work

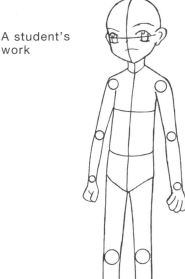

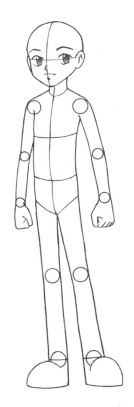

It may not be obvious, but even pros make mistakes. Can you pick out what is wrong with the sketch below?

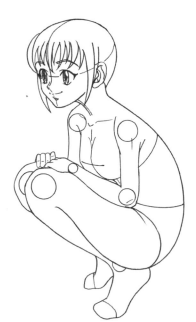

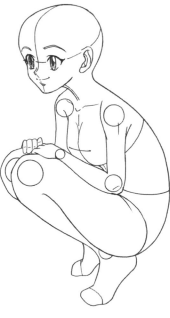

Got it?

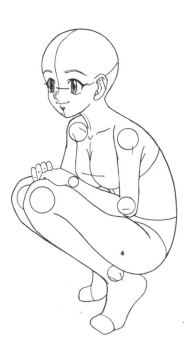

Common Mistakes

The most common problem with balance is the way the head is attached to the neck— a problem that can be seen in the example below.

The bones in the neck are not properly drawn, and the face is not three-dimensional.

Comparing the two with your naked eye, can you see why the one on the left looks strange? That's correct— the neck was drawn afterwards. This is an area where even pros make mistakes. You can even find this mistake in books that teach you how to draw.

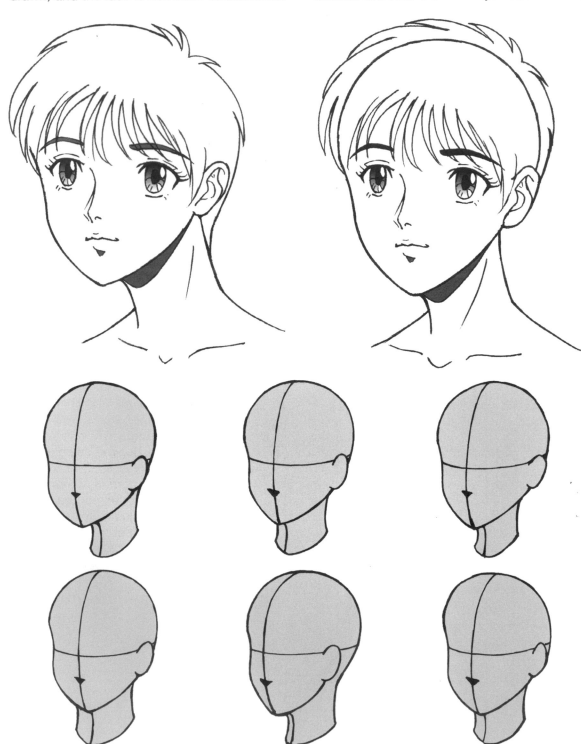

Attach the Neck to the Foot

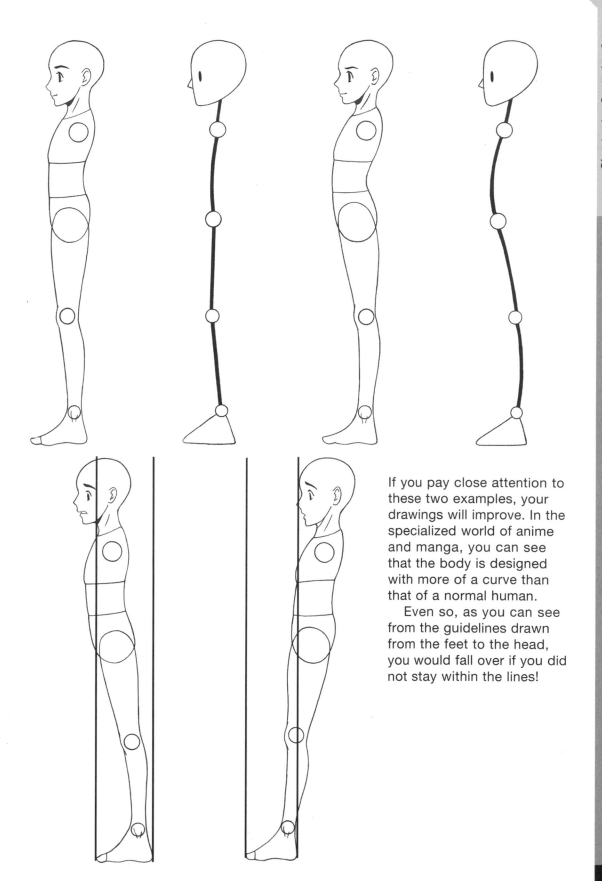

If you pay close attention to these two examples, your drawings will improve. In the specialized world of anime and manga, you can see that the body is designed with more of a curve than that of a normal human.

Even so, as you can see from the guidelines drawn from the feet to the head, you would fall over if you did not stay within the lines!

Position of the Feet From the Front

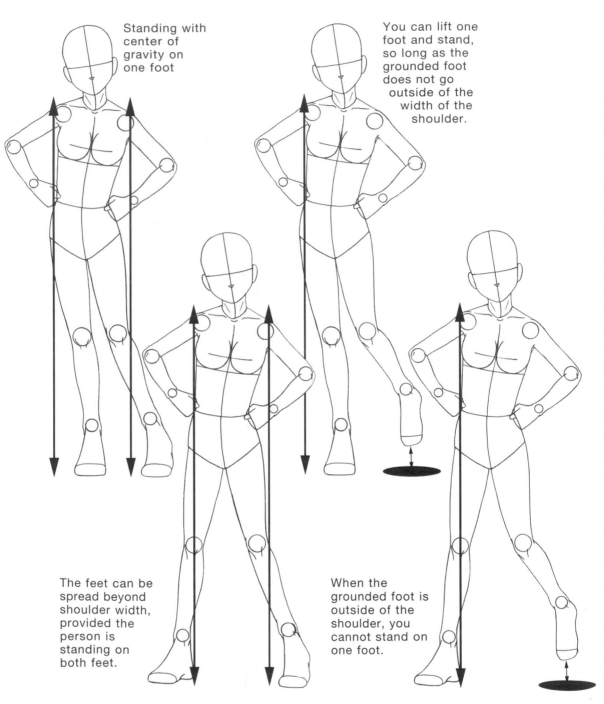

Standing with center of gravity on one foot

You can lift one foot and stand, so long as the grounded foot does not go outside of the width of the shoulder.

The feet can be spread beyond shoulder width, provided the person is standing on both feet.

When the grounded foot is outside of the shoulder, you cannot stand on one foot.

As seen in the drawings by the students, one common mistake is do draw both feet from the front. The center of gravity can be placed on either one foot, or two feet when they are spread out. Problems usually occur when the weight is only on a single foot.

The rule of thumb is to not allow the foot that is acting as the center of gravity to fall outside of the shoulder. If you actually tried to stand this way, you'd understand, but since there is no fear of an illustration falling, this mistake happens more than you would think.

This picture may not make a baby cry, but to the trained eye it will look strange and ultimately your picture will not look skillfully drawn.

Head & Body (1)

When drawing a single picture in your own style, the size of the head in relation to body is not an issue. But when working on a project with a team of animators or manga artists, you will likely have to draw the same character numerous times, or there may be a several illustrators who draw the same character in different places.

Once the head-to-body ratio is determined, keeping it consistent becomes an easy task. Europeans and Americans are generally 8 heads tall.

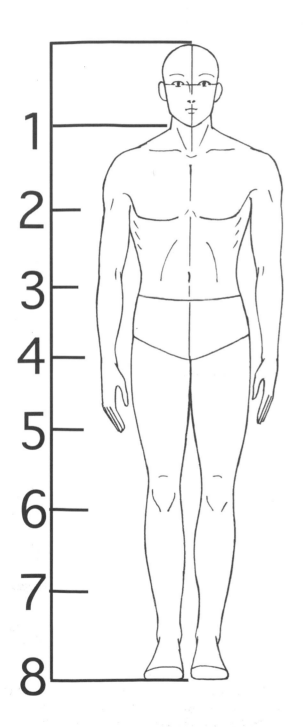

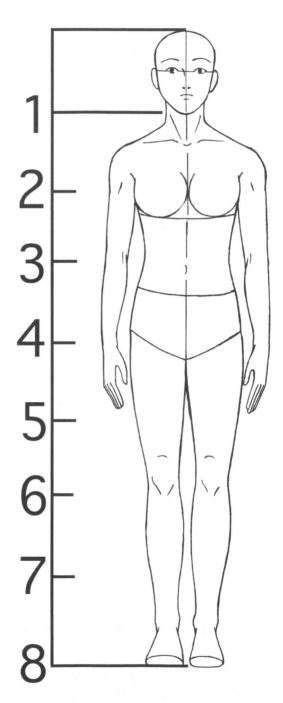

Head & Body (2)

Seven heads tall has become the standard for Asian characters, but this can vary depending on the overall design of the anime or manga.

Actually, in anime and manga, the character may seem 8-9 heads tall when it is only 7. This is because the body, arms and legs are all draw longer and thinner than in real life.

Have you set your own character's head-to-body ratio? Try to find the ratio that gives your character the best balance.

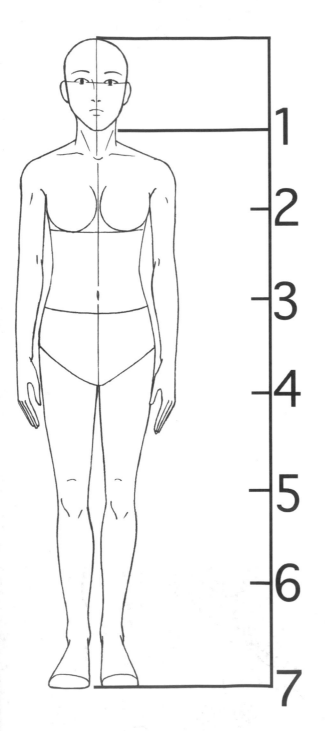

1
2
3
4
5
6
7

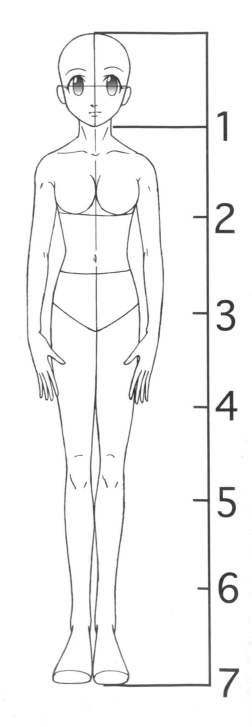

1
2
3
4
5
6
7

Chapter 2
Skeleton & Muscle

Body Frame

When you draw a character, you never actually draw the bones as seen here, but it will be something you will need to do in order to improve, and there may come a time as a pro when you have to draw a skeleton.

In addition to taking a long, good look at these examples, try drawing a skeleton at least once. It will help you predict how the parts of the body move.

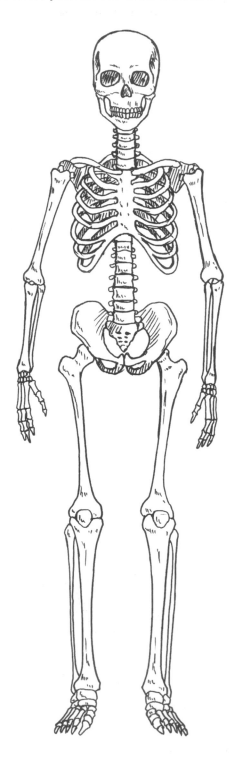
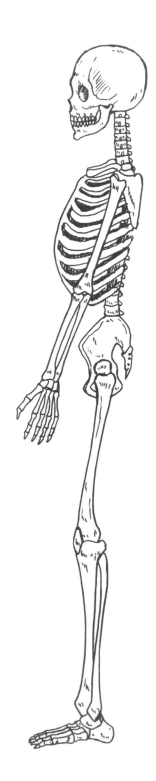

Think of the Body Frame in Simple Terms

If you had to draw the entire skeleton every time you drew a character, it would be too much work. It is better to start out more simply.

For the time being, we will call this early frame the "wire skeleton". The figures below show a progressively fleshed out frame. While we think of square boxes as our building blocks, we switch to cylinders as we build out to the hands and feet.

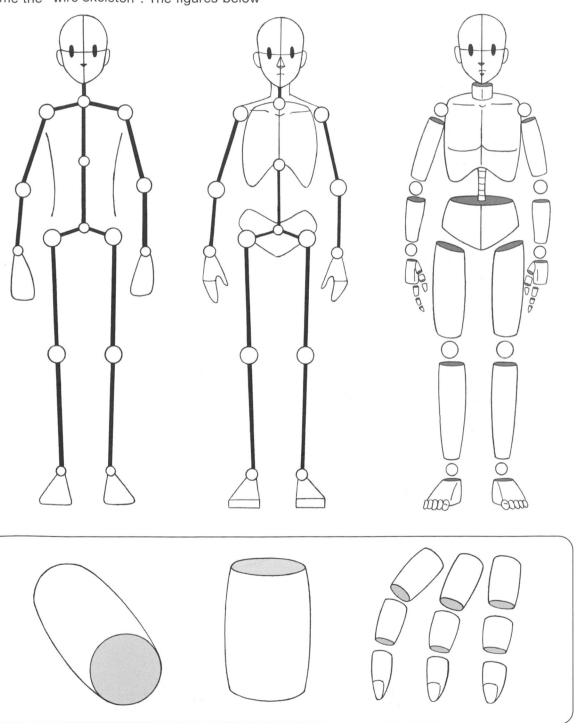

Pose Your Figure Using the Wire Skeleton

Before you flesh out the muscles and face, set your figure's pose, size, and balance with the wire skeleton. This way you can remove any flaws in your design early on. Even though it is rarely as clean as you see here, all animators and manga artists use this method.

Even if you can draw the muscles, your drawing will not look good unless the pose and balance are good as well. Regardless of the varying levels of musculature, the underlying pose itself is the same.

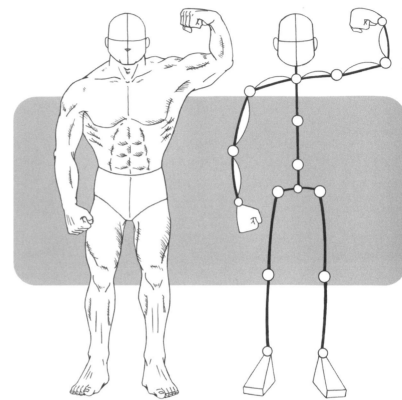

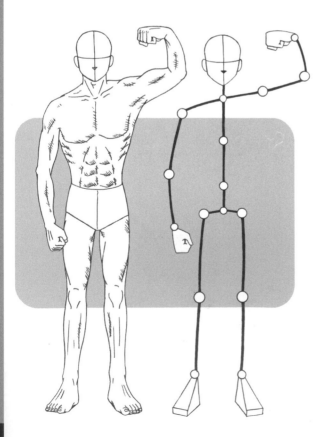

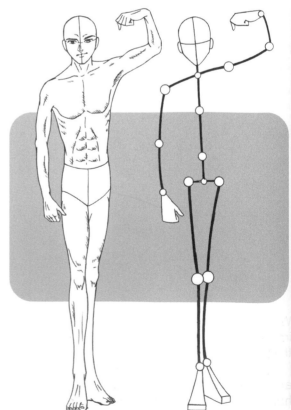

Even Anime and Manga Characters Have Bones (1)

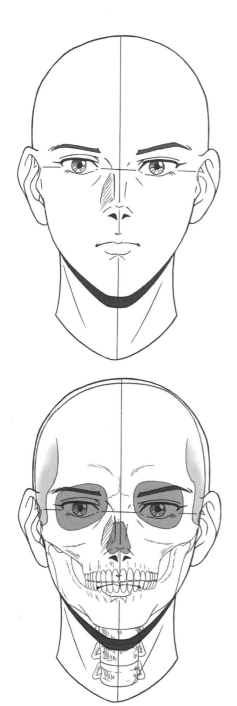

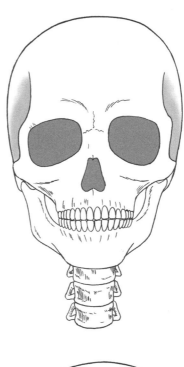

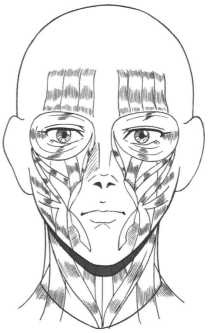

While it is not necessary to place that much importance on the entire skeleton, you should think a lot about the shape of the skull.

While your characters may only exist in anime or manga, if they are based on humans, you can set the shape of the skull, even if it is somewhat stylized.

You may not be drawing the skull itself, but keep in mind that your three dimensional character does have one when you are drawing both the front and profile of your character's face. Can you draw your character's face and profile?



Even Anime and Manga Characters Have Bones (2)

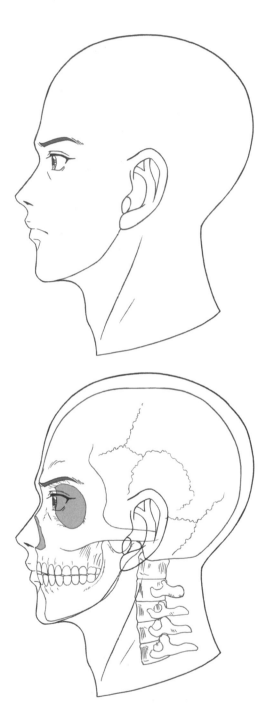

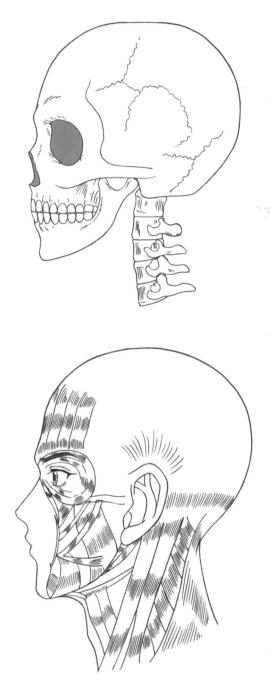

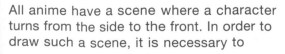

All anime have a scene where a character turns from the side to the front. In order to draw such a scene, it is necessary to understand and capture the shape of the skull and structure of the facial muscles as shown in the examples above.

Even Anime and Manga Characters Have Bones (3)

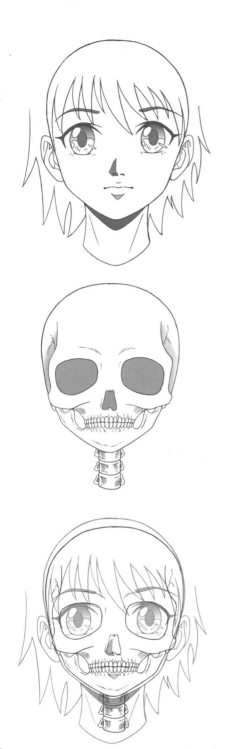

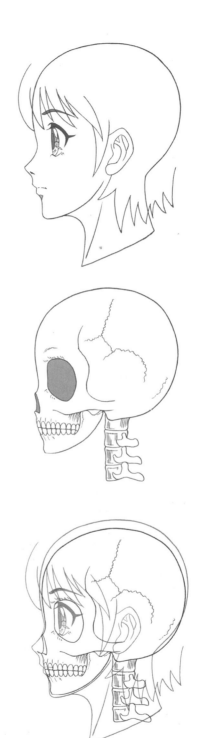

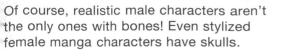

Of course, realistic male characters aren't the only ones with bones! Even stylized female manga characters have skulls.

Always remember the position of the nose and eyes, and shape of the jaw. If you can master these, you should do fine

Bones and Muscles (1)

It is not necessary to remember the names of the bones and muscles of the body, but you must know the shape of the muscles when you are drawing them. You should understand what lies beneath the surface to accurately portray the shape of your character.

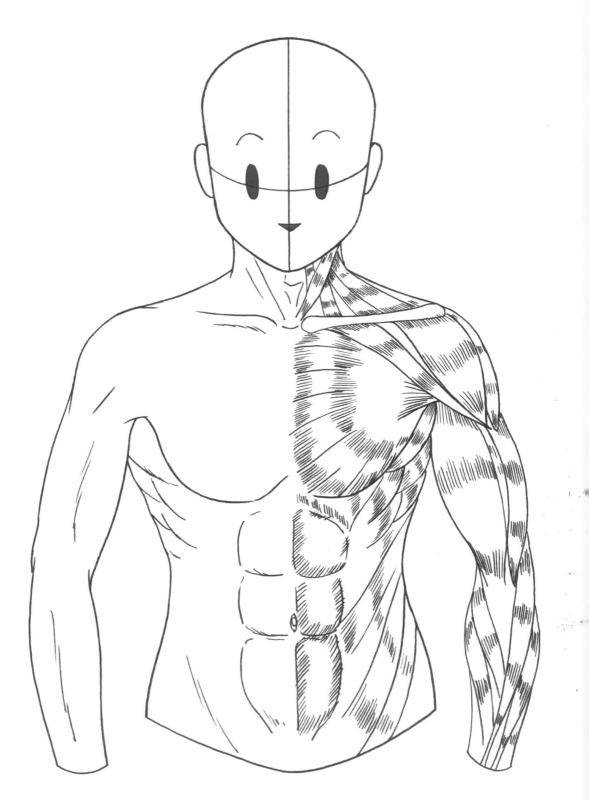

Bones and Muscles (2)

Take a good look at the muscles that are tensed when raising the figure's arms.
Note the muscles in the shoulder contract and are obscured.

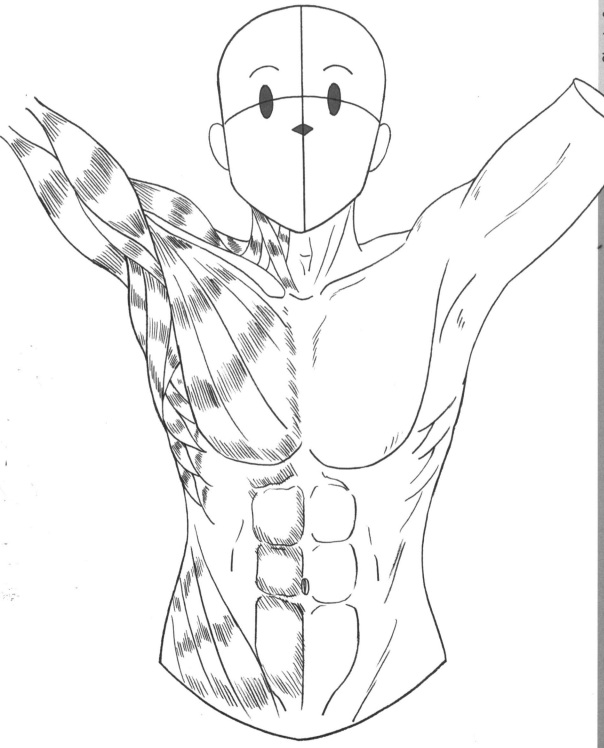

Bones and Muscles (3)

When drawing the back, it is important to remember to draw the line of the spine and the dense shoulder blades.

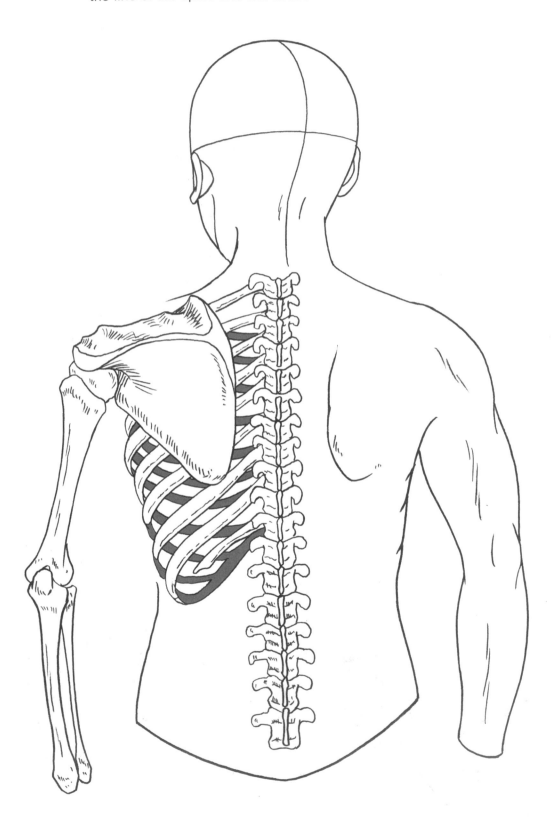

Bones and Muscles (4)

Because the muscles of the back are interwoven in a
complex pattern, they are rarely shown in anime and manga.

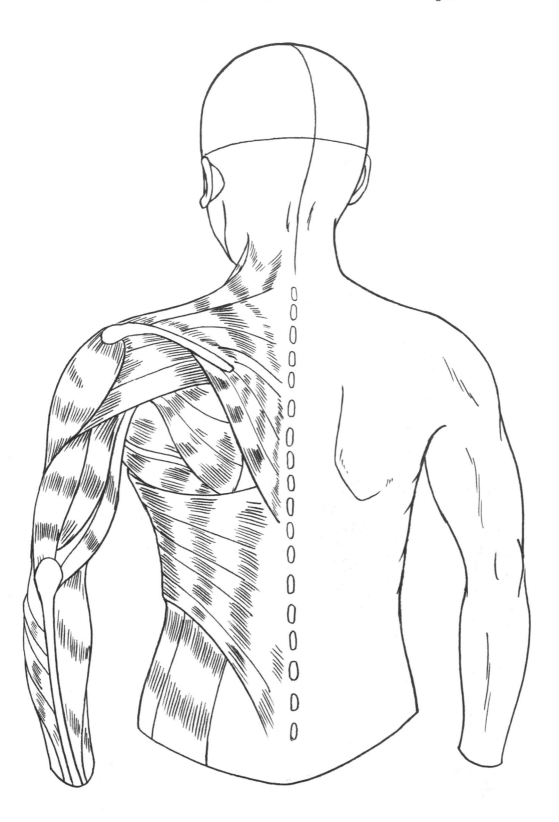

Bones and Muscles (5)

When you look at the figure from the side, you can clearly see how the arm is at-tached, the muscles surrounding the ribs, and the shoulder blades.

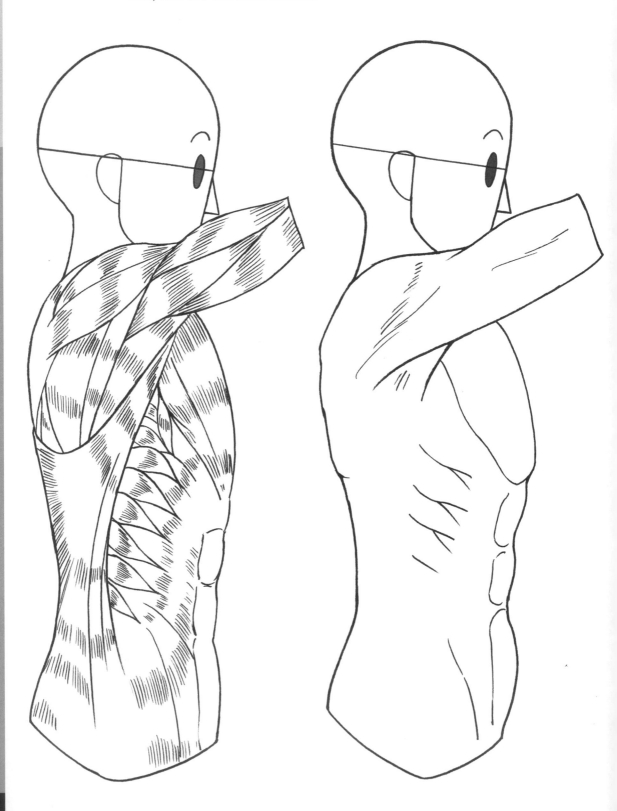

Bones and Muscles of the Arm

Take a look at the shapes of the bones and muscles from the shoulder to the hand. In anime and manga, artists depict varying levels of detail, trying to be conscious of the bones and appropriate swelling of muscle depending on the project and character design. For male characters, they will be larger; for female characters, the detail will be subtler. In some works, the details of this portion of the anatomy are almost non-existent. Still, just because they are not there, don't assume that the professional artist does not know how to draw them.

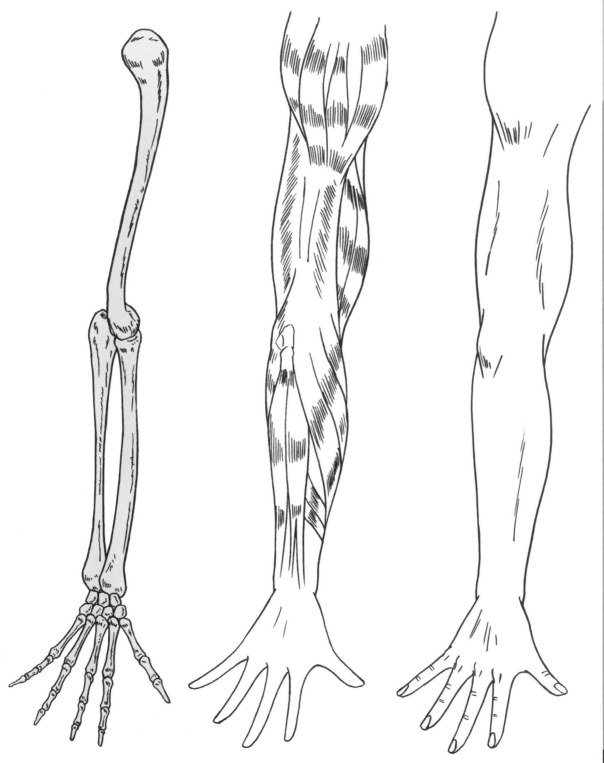

How to Capture the Shape of the Hand (1)

Similar to the face, finding the balance for the hands and fingers of your creation will determine just how skilled an artist you are. I'm sure there are many of you for whom the hands cause a lot of worry.

Once again, it is not important to remember the names of the bones, but rather to be fam-iliar with where the joints are and how they move. The first step to drawing a hand skillfully starts with being able to draw each finger.

How to Capture the Shape of the Hand (2)

Try thinking of the joints of the fingers and how each moves in the same way you did with the wire skeleton. In order to capture three-dimensional space, build up to square boxes and then replace them. Also consider the thickness of the hand, but think of it separate from the fingers. If you think of the fingers as extending from the fleshy part of the palm, they will be easier to draw. Once you comprehend the space, change from boxes to cylinders to reflect the true nature of the hand.

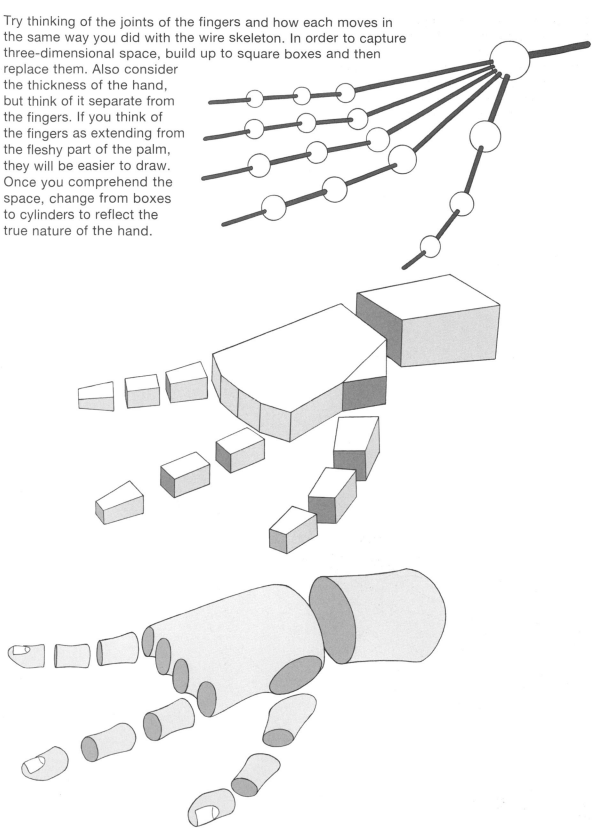

Drawing the Bones and Muscles of the Front of the Leg

The shape of the muscles similarly influences the leg. If you do not have a grasp of the shape of the muscles in the thigh and calf, it will be much harder to draw the legs.

Aside from knowing the muscles, the most important thing to recognize is where the joint is positioned in the kneecap.

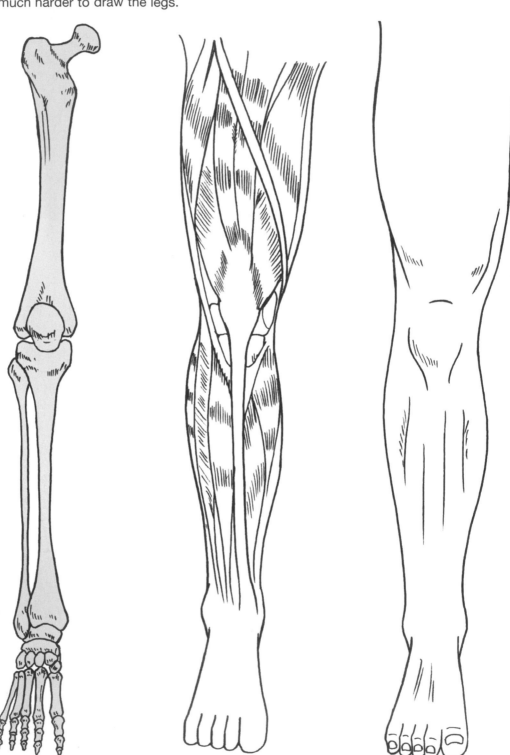

Drawing the Bones and Muscles of the Side of the Leg

When you look at the leg from the side, the muscles are more immediately apparent. The structure is particularly obvious in the back, where the shape of the thighs and calves are a fulcrum that form a gentle slope that links the crotch, knee and ankle.

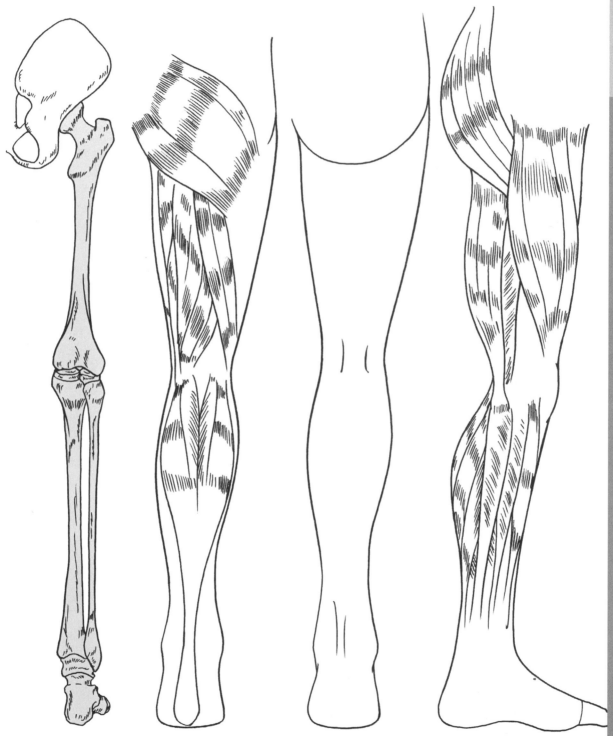

Lines and Bones of the Foot

There is no need to pay special attention to the muscles of the feet. Your line drawing will show the fleshed-out shape of the bone structure below. The heel can be especially difficult, but the important thing is to show the contours of the ankle.

As you can see, when looking at the ankle from the side there is some thickness, but more than shading, you would define it by staggering the length of the left and right sides. Of course, the longer side is where the shading would go.

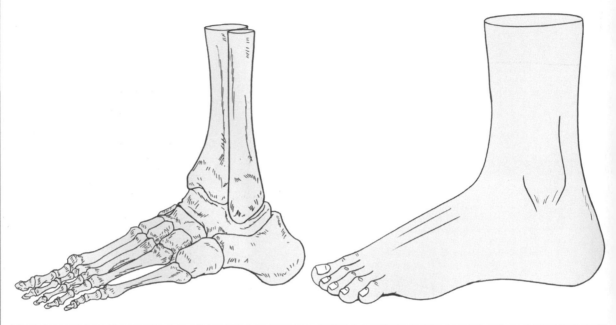

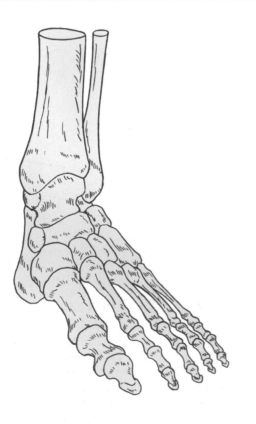

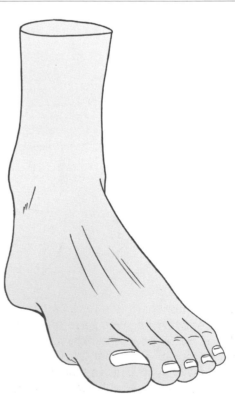

Examples of Drawing the Hand (1)

You can tell how hard it is to draw hands by the number of people who have problems with them. Some people believe it is too difficult to represent the hand three-dimensionally. It is the movement of the fingers in combination with the hands that causes the problems. Those who understand the bone structure of the hands and can capture the space will be able to draw them, but it is not an easy thing to memorize. The following are several examples of poses of the hand in motion. Even if you just copy them, memorize the shapes and you will continue to improve your ability.

Examples of Drawing the Hand (2)

Examples of Drawing the Hand (3)

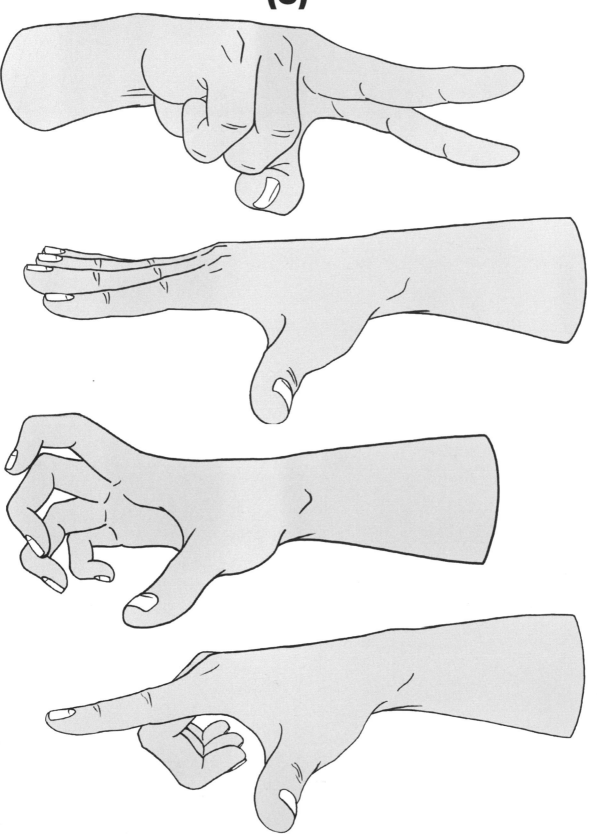

Examples of Drawing the Hand (4)

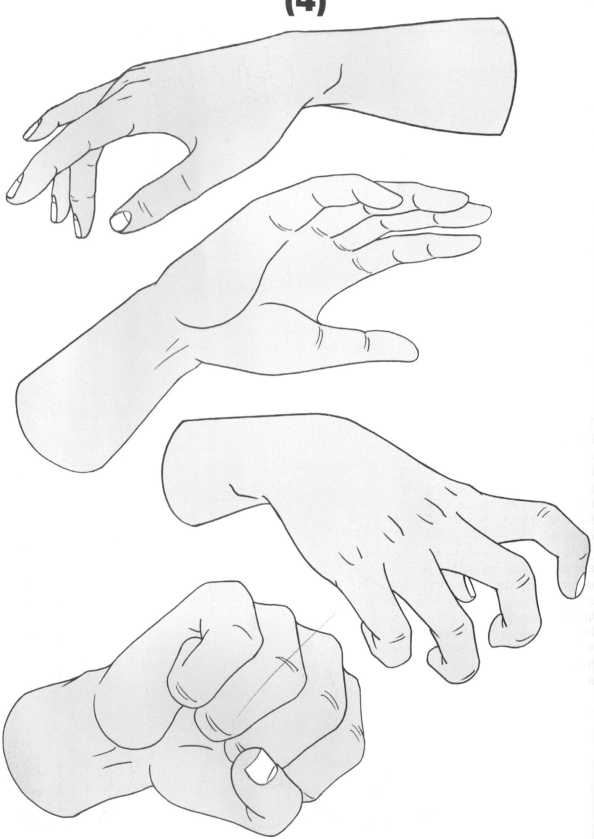

Drawing the Shape of the Foot (1)

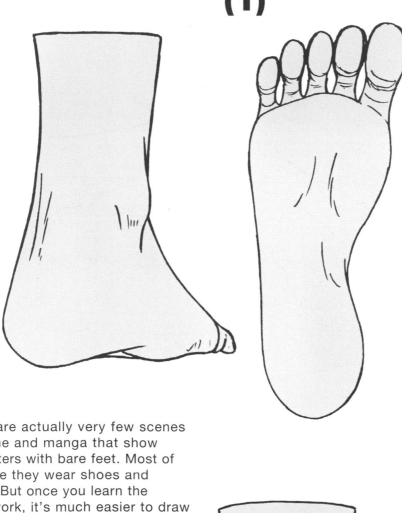

There are actually very few scenes in anime and manga that show characters with bare feet. Most of the time they wear shoes and socks. But once you learn the framework, it's much easier to draw the shape that the foot takes when covered.

As previously explained, the feet are extremely important when determining balance and position in animation and manga. Even more important is whether the sole of the foot is actually touching the ground. When a person is standing, you have to show that the foot is flat on the bottom of the box that forms the

47

Drawing the Shape of the Foot (2)

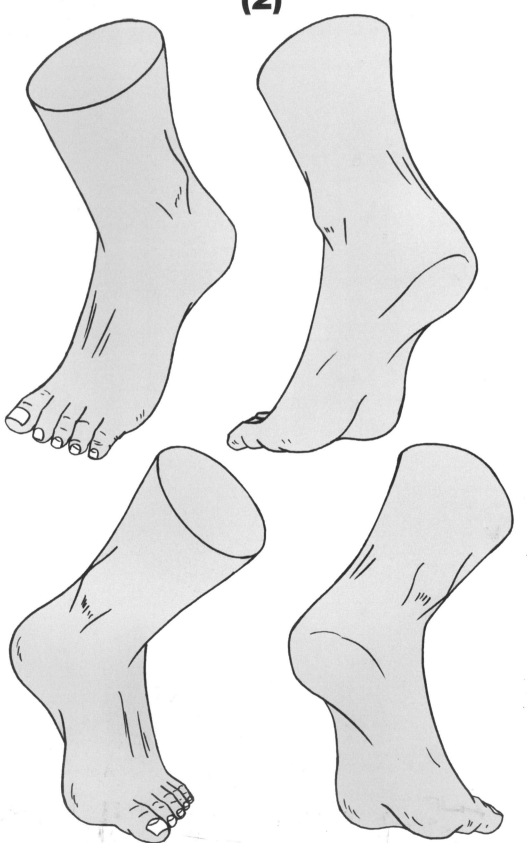

Basics of Drawing Shoes (1)

Ultimately, drawing feet means drawing shoes. The methods of drawing shoes vary depending upon character design and shoe styles. This is where the square box really comes into play. Notice how the surface of the ground and bottom of the shoe have the same purses and that they meet perfectly. This becomes the foundation for depicting the character in relation to the landscape in a truly three-dimensional way. Sneakers and other shoes without heels are the easiest to memorize, but start off by trying the two types of shoes shown below.

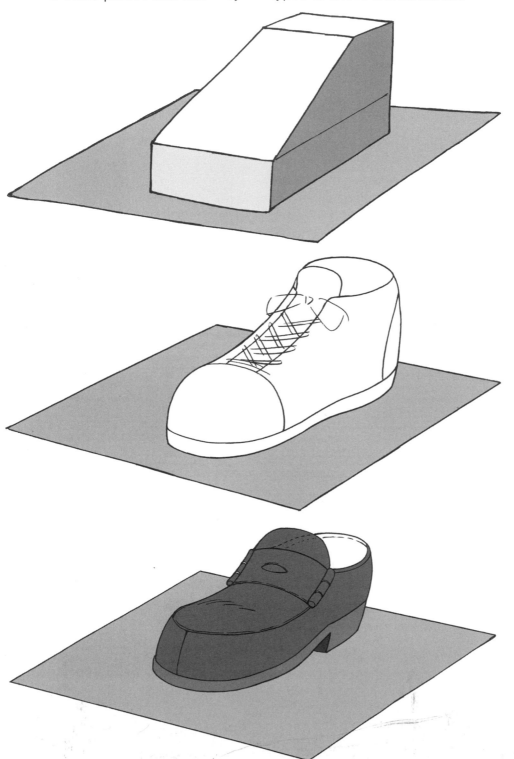

Basics of Drawing Shoes (2)

This time, try drawing the same shoes from the rear.

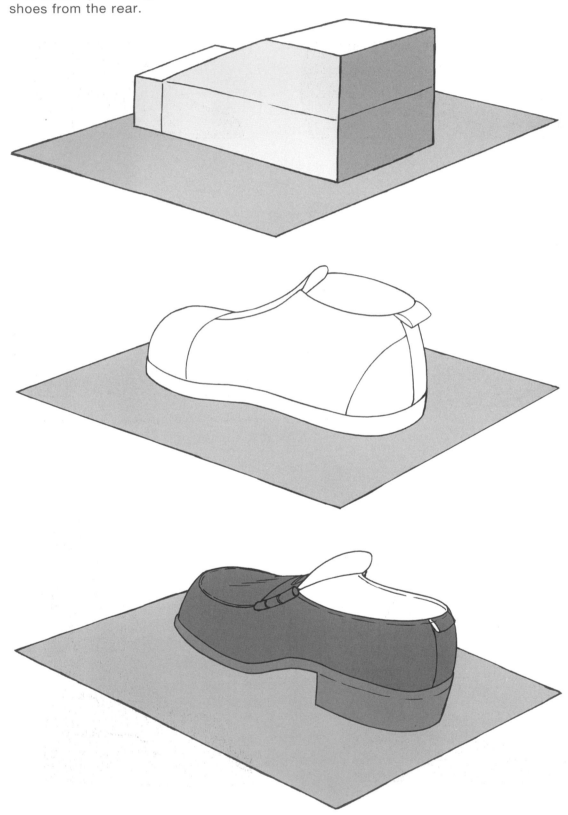

Basics of Drawing Shoes (3)

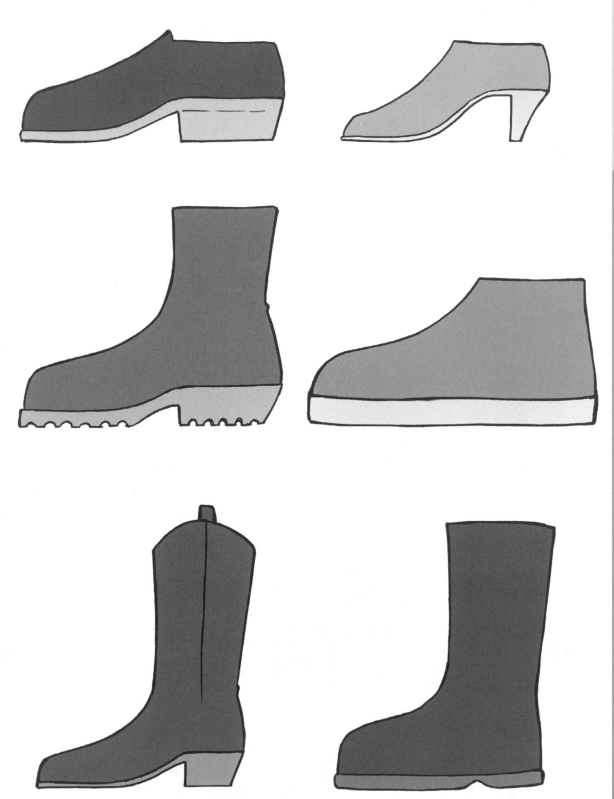

Various Angles of a "Realistic Type" Face (1)

Like most people, you are probably most interested in improving your skills at drawing faces.

But hold on just a moment. As we've explained up to this point, the key to becoming a better artist is to capture the object in three-dimensional space. The same can be said for the face. You don't have to actually draw the box. Always be thinking about the angle of the head and the direction of the face as you create a rough sketch, and add roundness when you draw the eyes and mouth.

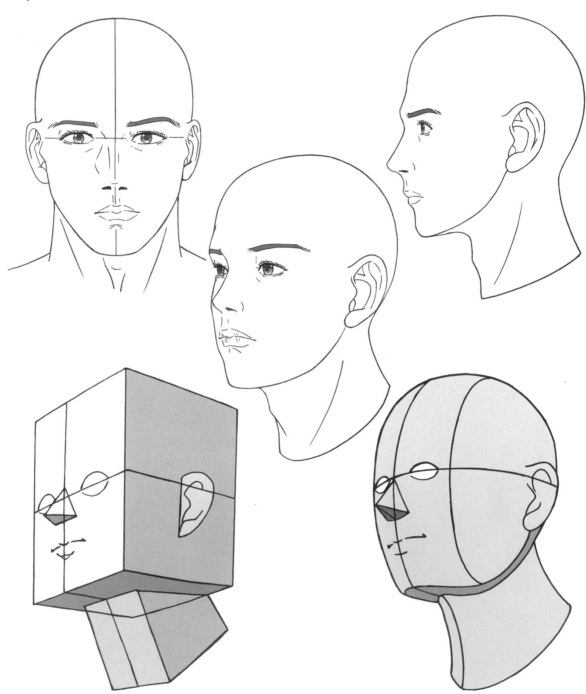

Various Angles of a "Realistic Type" Face (2)

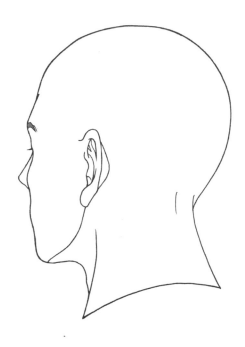

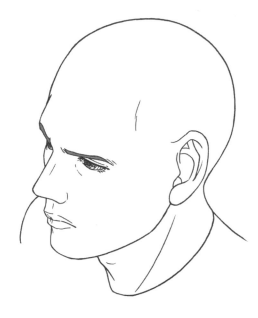

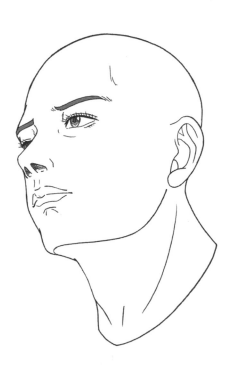

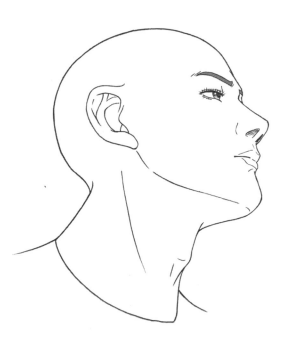

Various Angles of a "Realistic Type" Face (3)

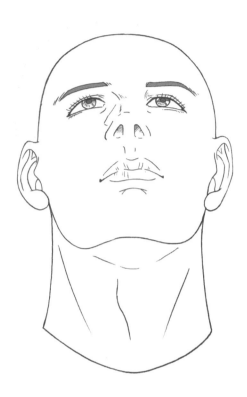

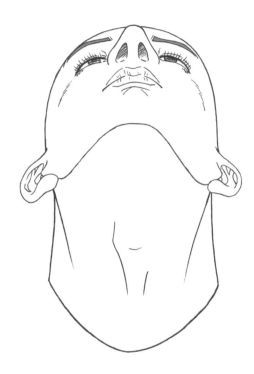

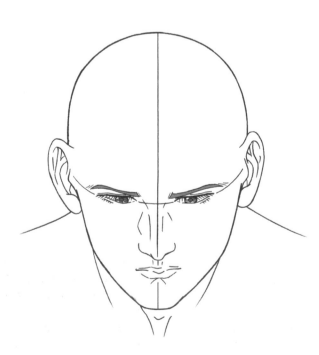

Various Angles of a "Manga Type" Face (1)

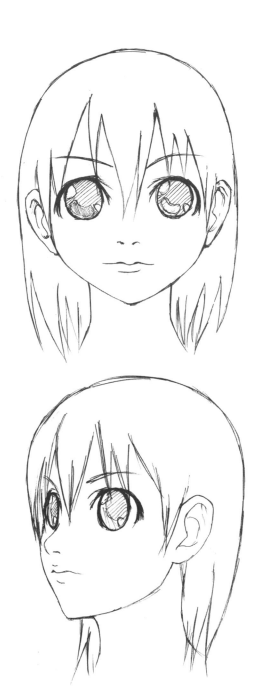

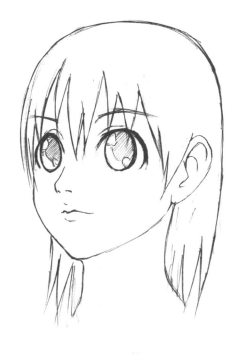

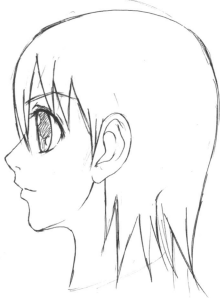

You can practice the "realistic type" face with a sketch, rough sketch, or croquis. But how would you practice drawing manga?

Which features will you enhance? Which features will you reduce?

When you create a "manga type" character, you will deform some of the features for a cartoonish feel.

When you place this exaggerated figure in the box, it will be easier to decide on the details.

In anime, there will be a character chart like you see here, depicting the character's expression at various angles. Those who endeavor to become

Various Angles of a "Manga Type" Face (2)

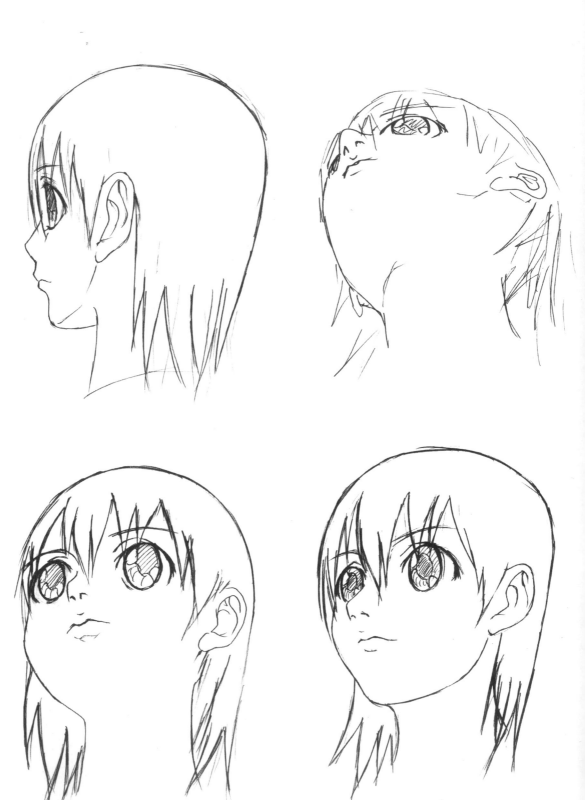

Various Angles of a "Manga Type" Face (3)

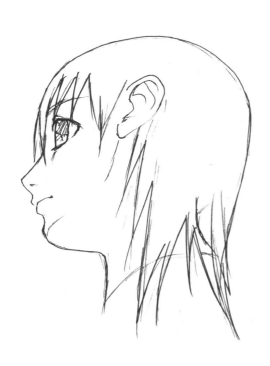

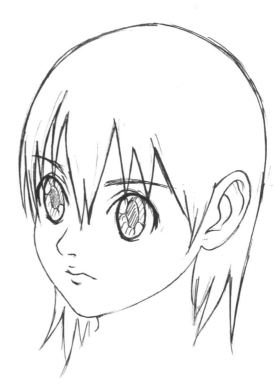

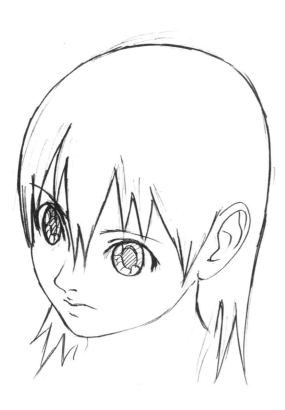

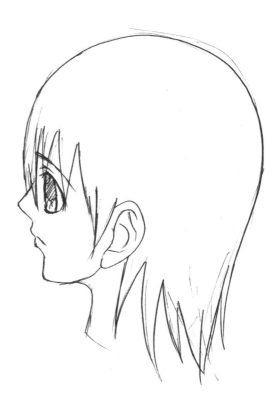

Examples of Difficult Angles of the Face

Even pros consider drawing a face from above or below difficult. The figures I have drawn below can serve as examples.

Practice drawing each angle on your own character.

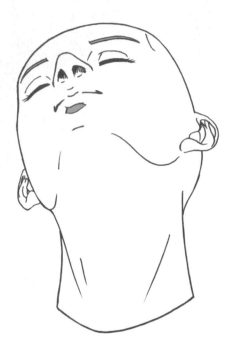

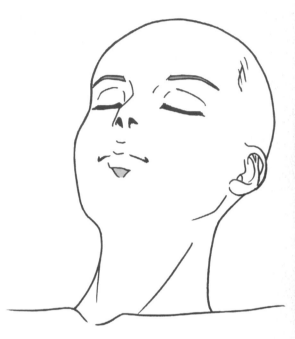

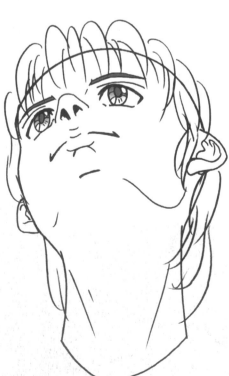

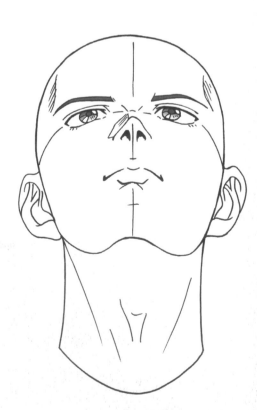

Chapter 3
Character Design
Fundamentals

Breaking Down Body Types in Character Design

Keeping in mind the basic methods of drawing, let's try drawing actual character body designs. In anime and manga, before drawing the eyes, nose, and mouth of a character, a silhouette is first drawn so you can get a general feel for the character.

Your work needs more than just a protagonist. There are typically tens or even hundreds of characters in each manga or anime. I am sure you have already discovered that there is a limit to how many characters you can create simply by

changing the eyes, mouth, or hairstyle.

Try changing the shape of the body and creating characters who are taller, or fatter.

Not only will this create more variations among your characters, it will also make the story more interesting. It will also make the protagonist easier to draw. In addition to conforming to the philosophy of the professional world, it will help improve your sketching and design abilities, killing two birds— no, three birds— with one stone.

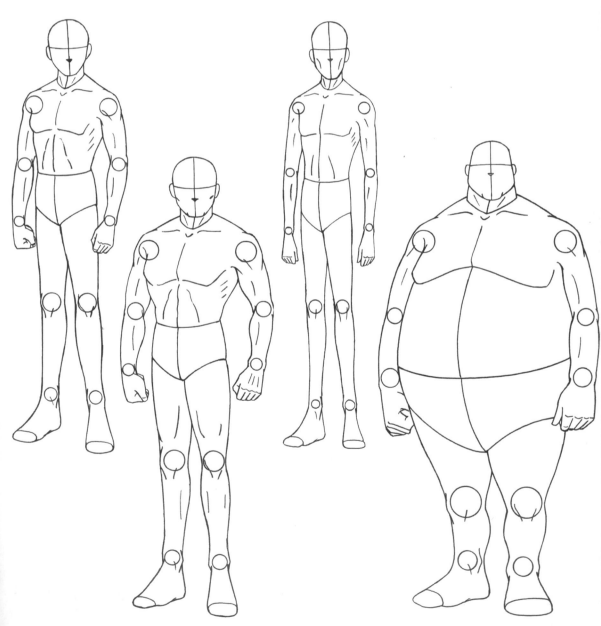

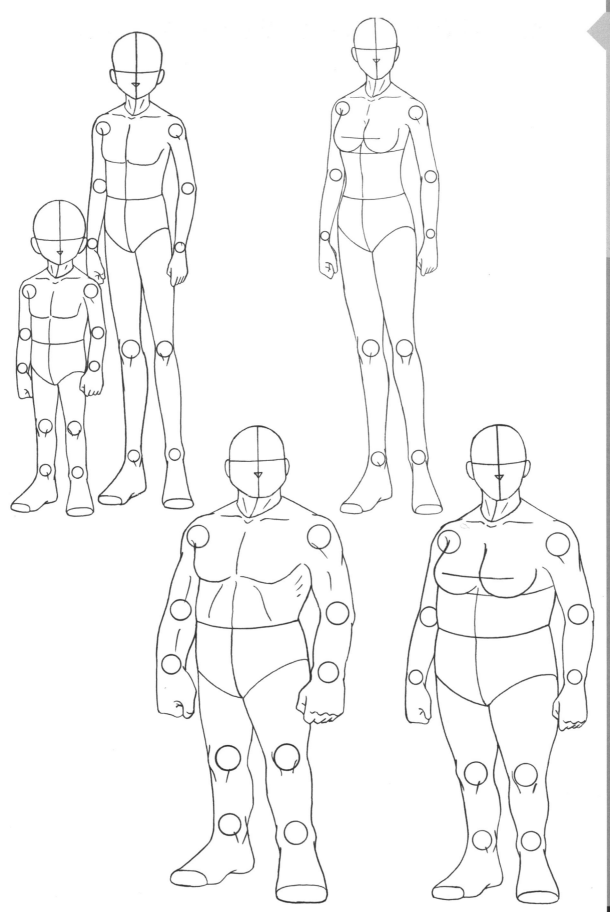

Character Design:
3 Views of a Male Protagonist

In an animation company, it is necessary to create a character chart for those artists who will be assigned to draw that character. The chart includes three angles of the face, the full frontal shot, the side, and the back.

These angles are needed to design the costume to fit the physique, and as explained in Chapter One, to capture the space occupied by the character.

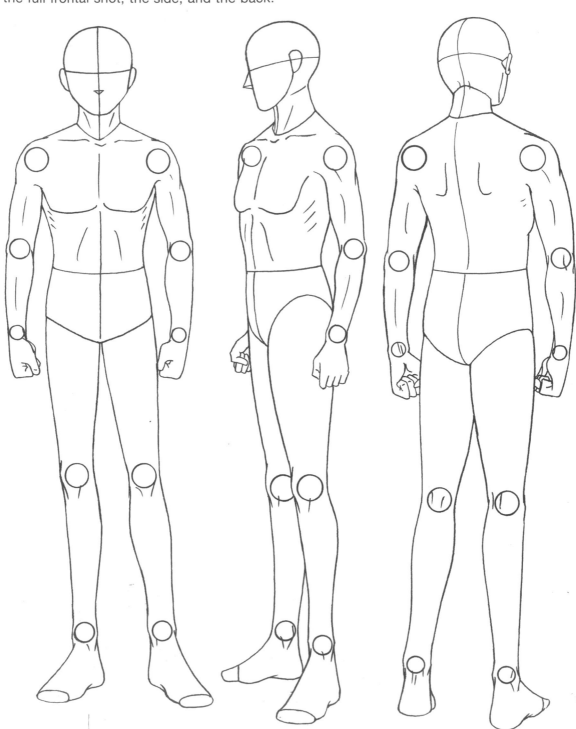

Character Design:
3 Views of a Female Protagonist

In addition to the male protagonist, I have added the three views for a female character. Compare the narrower proportions to those of the male on the previous page as well as the sense of personality.

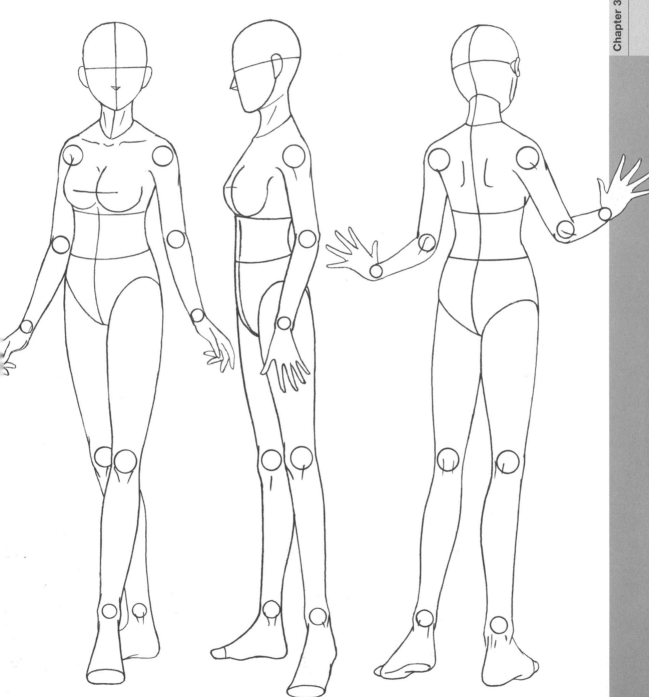

Depicting Age Differences

In addition to body types, characters can also be differentiated by their ages. Such details include wrinkles of the face and clothing, their posture, the bend of the waist, and the head-to-body ratio.

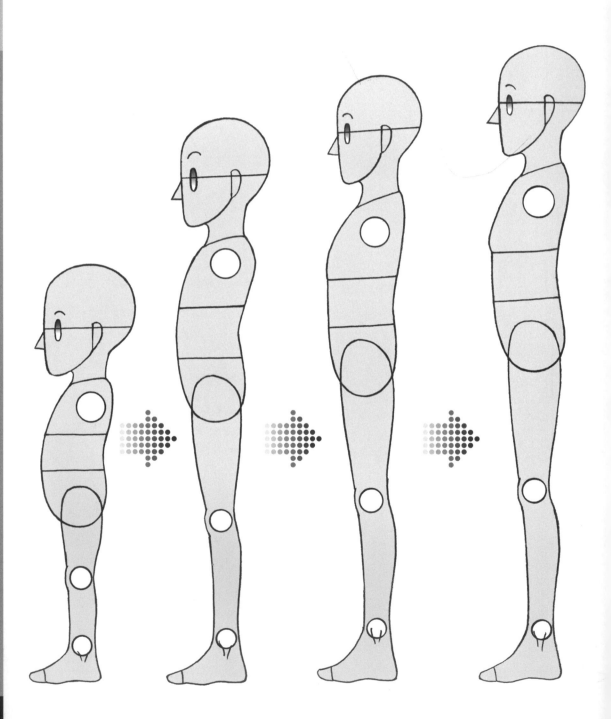

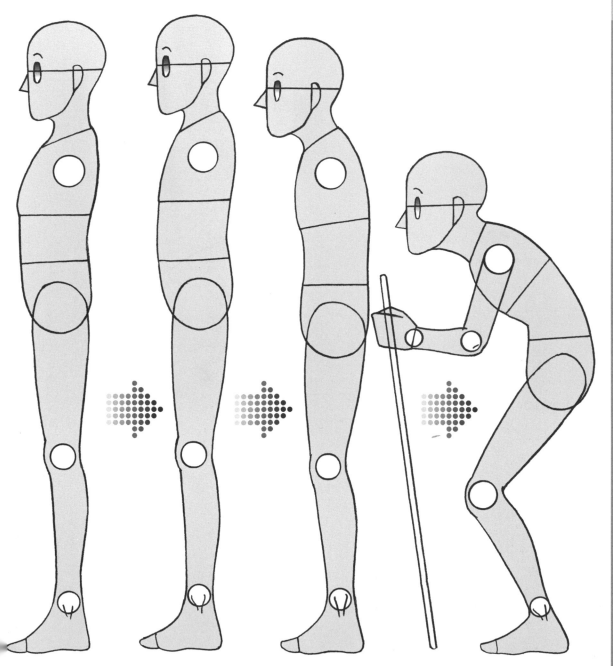

The Aging Face — Male

There are various methods to depicting age progression. Examine the character designs below, noting the position of the eyes, the increased roughness in the face, increased wrinkles, and sagging muscles.

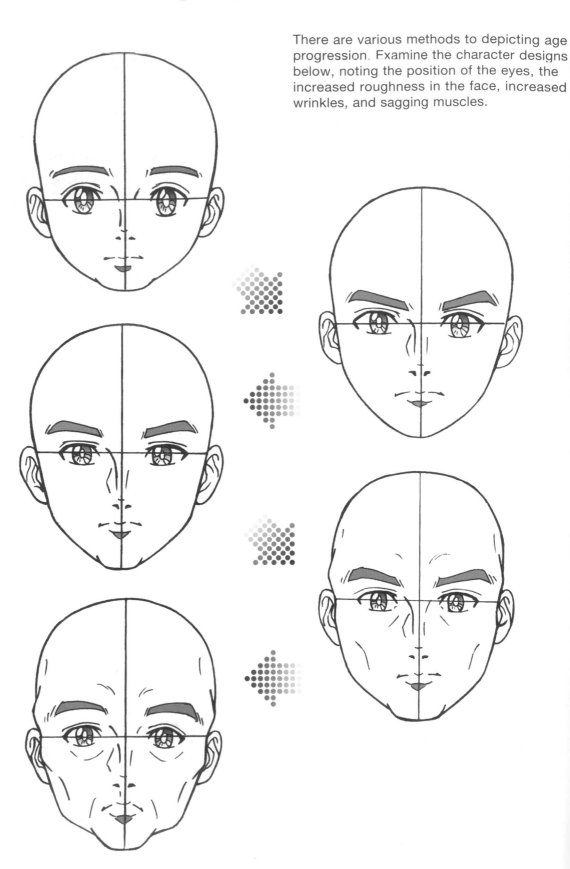

The Aging Face — Female

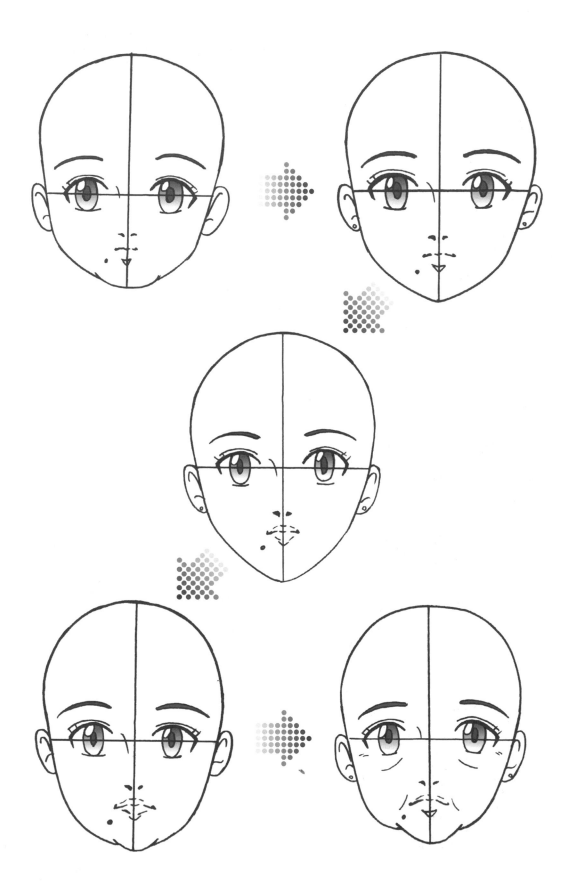

Practice Drawing the Difference Between Male and Female Characters— "Manga Type"

This book introduces various methods for drawing characters, but your drawings will not and should not look exactly like mine. How will your characters look? Try drawing the silhouettes of your characters without facial details. Practice both male and female types side by side while paying attention to the width of the shoulders and build of the bodies.

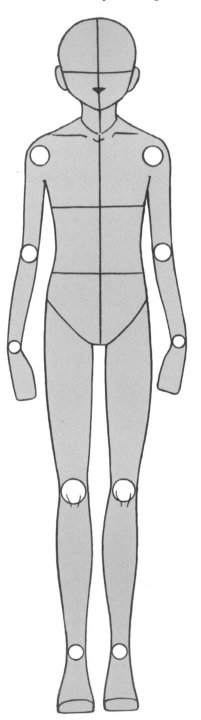 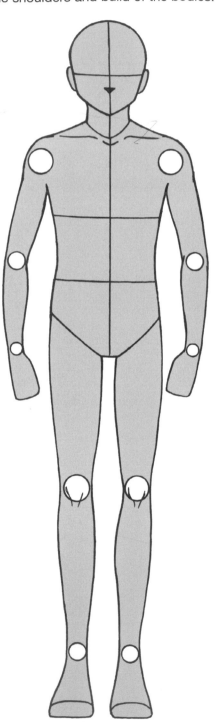

Practice Drawing the Difference Between Male and Female Characters— "Realistic Type", Front

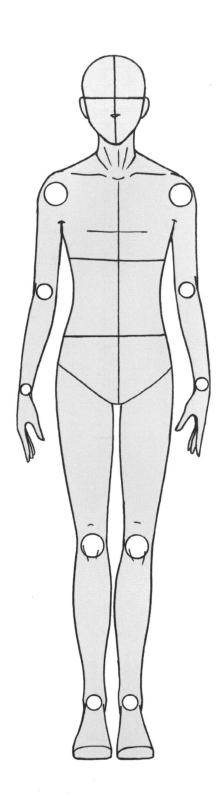

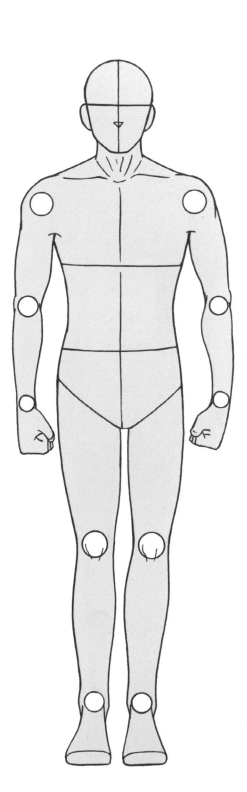

Practice Drawing the Difference Between Male and Female Characters— "Realistic Type", Lower Angle

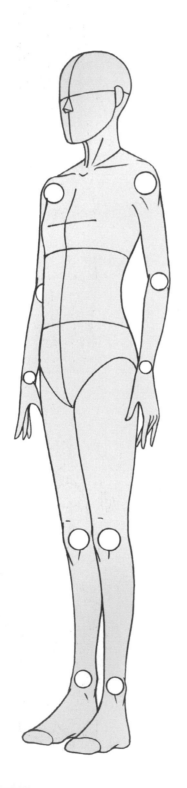

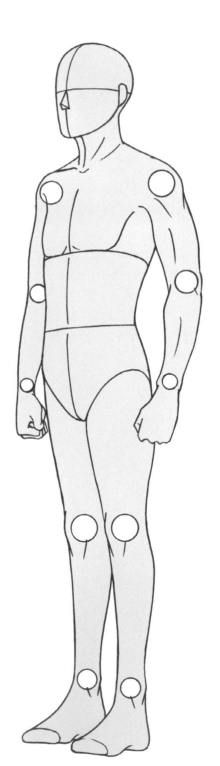

About Children

When drawing children and babies, you need not think about the differences between boy and girl body types. Simply practice different poses for children such as those shown in the examples below.

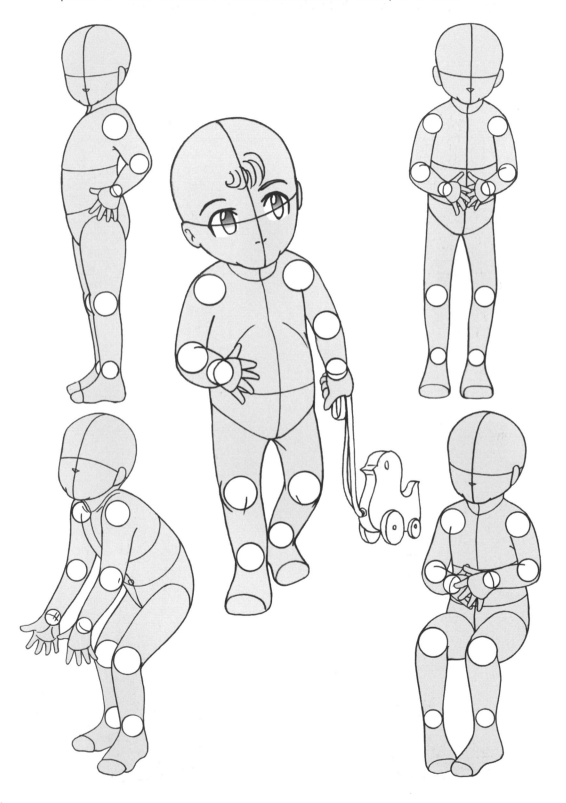

Design and Head-To-Body Ratio

Just because humans have a 7-8 head-to-body ratio, you've probably noticed that this rule is not strictly followed in anime and manga. How many heads tall will your creation be?

Any ratio will do if your design and balance are consistent. The technique may be difficult, but this is where character design gets interesting and it is the second step when creating your work of art.

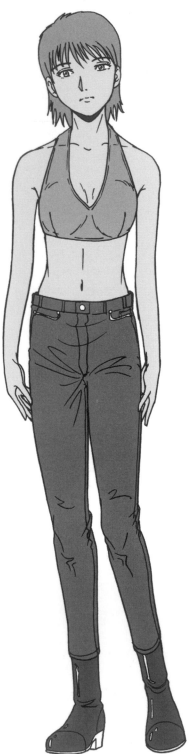

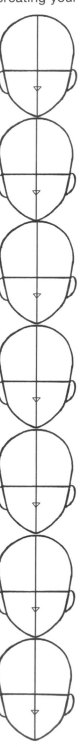

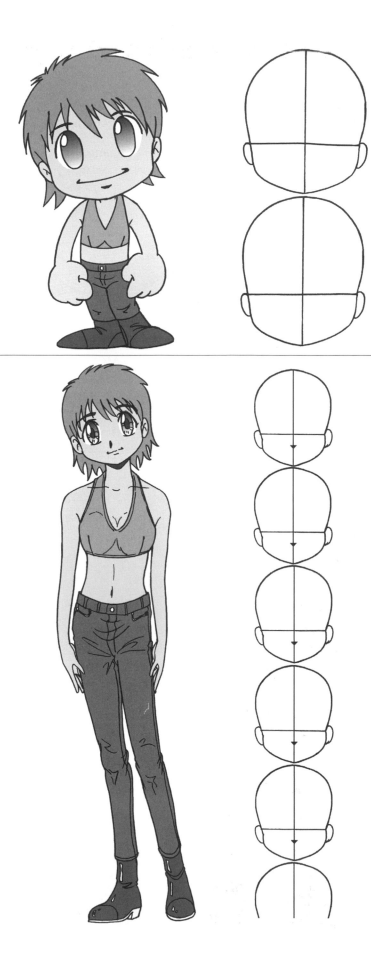

Adjust Your Artwork Accordingly

There is another point worth noting about the physique. We have discussed the muscles and bones, but you shouldn't draw either of these too realistically. In addition to achieving the correct head-to-body ratio for your character, ask yourself how realistic should it be? You can't just blindly draw the muscles in a realistic manner. In some areas, it will be necessary to reduce the detail, or you may have to change the sizes of the hands and feet to perfect the balance. This is not a decision I can make for you. I recommend you try a number of different designs to get a feel for it yourself

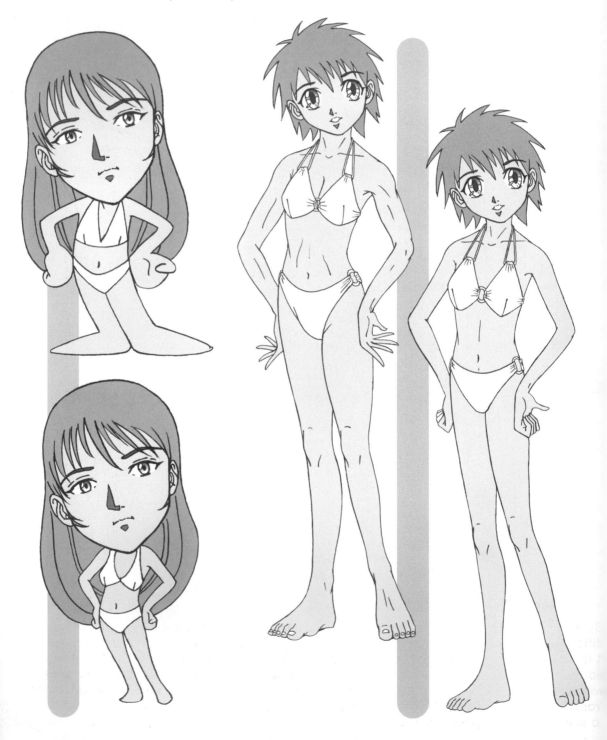

Set the Tone by Changing the Angle

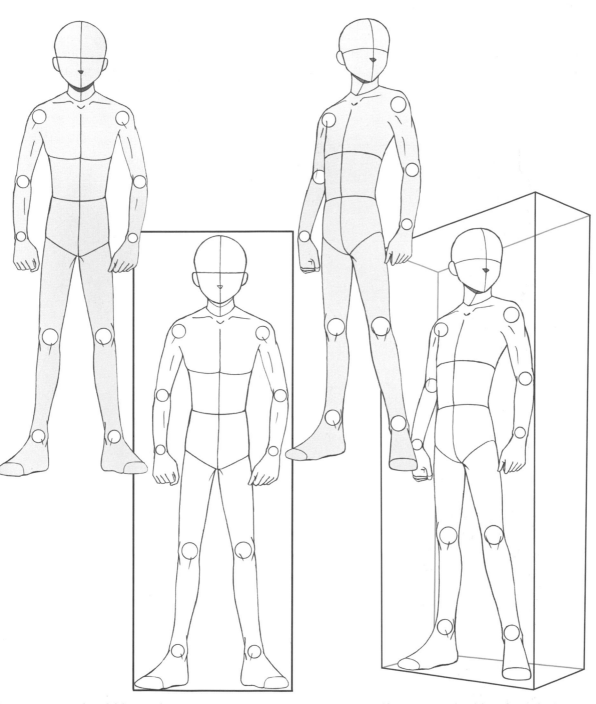

By now you should know how to draw the difference between men and women. Now it is time to take what you have learned and add poses. To create a dynamic effect, you will want to be able to draw your character from different vantage points. For example, to show a powerful pose, draw your character as if you were looking from below. If your character is downtrodden, draw it from above. It takes more than the ability to draw a three-dimensional character to be an artist; you must also plan how you want to show the character as well.

Changing the Angle to Produce Your Desired Effect

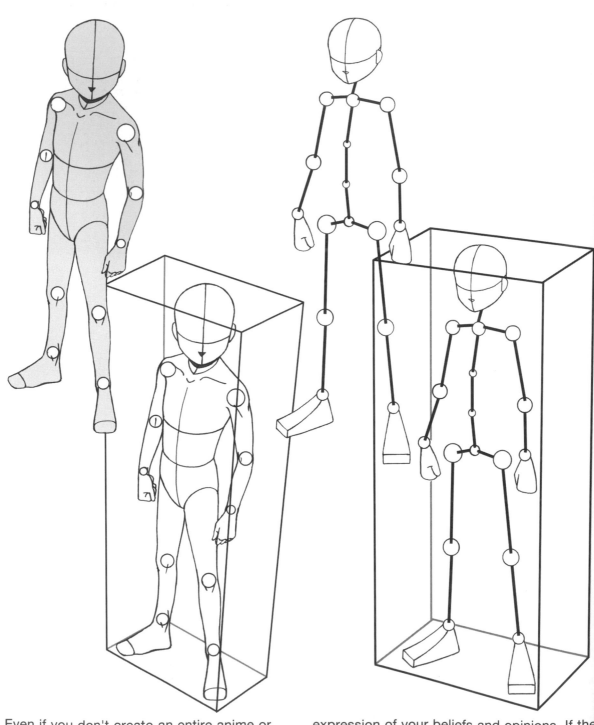

Even if you don't create an entire anime or manga, or if you do one-shot creations such as illustrations or posters, you should carefully plan the angle at which you will show the character since it is an important expression of your beliefs and opinions. If the angle of the pose is not carefully considered, you may inadvertently send the wrong impression for the tone of your drawing.

Difficult Angles

Let's say your character is sleeping. With a little practice, it is easy to show them from the side, but if you draw them lying head or feet facing front, it can be very difficult to capture the depth of the purse. Still, try to practice this angle because if you can express the depth well, it is a sign of a skilled artist.

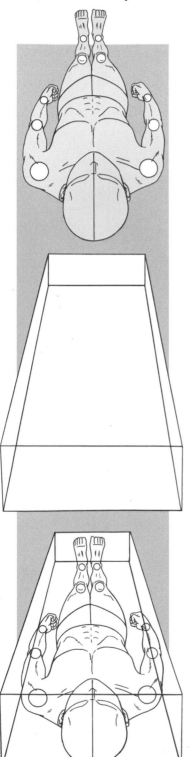

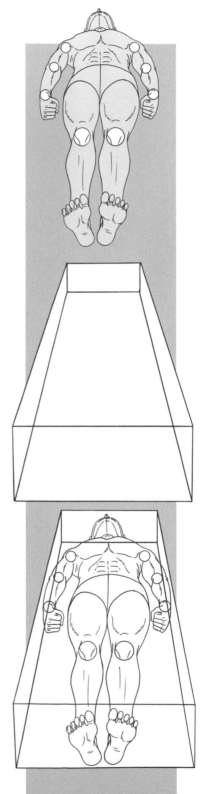

Chapter 4
Sample Poses

From here on we'll be practicing various poses for your character. Whether you can successfully pose your character or not, and whether you can do it for both standing and sitting poses, will make or break your creation. You didn't think you would just have your character standing around all the time, did you? Most people don't realize how much thought goes into deciding details like how the hands will be posed. I go through the same process myself. Once the story and character has been decided, it's easy to pose the body and achieve balance.

Skilled artists can portray so much with just a simple pose. How do they do it? Truth be told, there are a number of standard poses in anime and manga, and they choose the correct one for the desired effect.

I have included a number of these poses on the following pages. Improving your ability to draw these poses will be a shortcut to improving your overall skills. Try copying the poses you see in this chapter, using your own character, to help commit these methods to memory. The more you practice these poses, the better you will become.

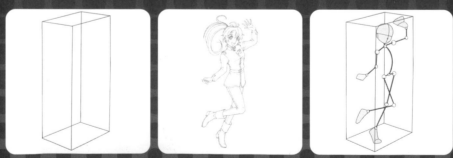

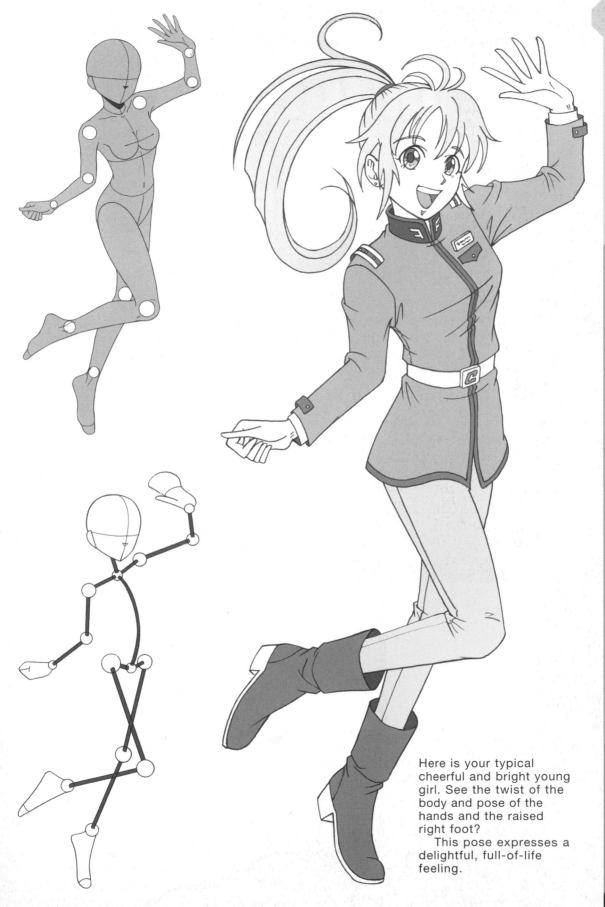

Here is your typical cheerful and bright young girl. See the twist of the body and pose of the hands and the raised right foot?

This pose expresses a delightful, full-of-life feeling.

The "Doing Nothing" Pose

At first glance, this pose seems to have little meaning to it. But the personality and feeling of the character are expressed through the open or closed hands and placement of the feet.

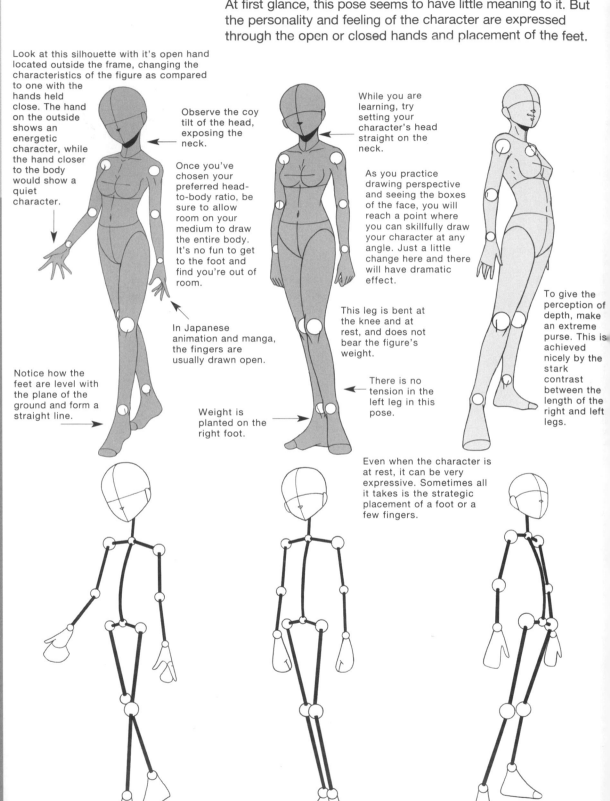

Look at this silhouette with it's open hand located outside the frame, changing the characteristics of the figure as compared to one with the hands held close. The hand on the outside shows an energetic character, while the hand closer to the body would show a quiet character.

Observe the coy tilt of the head, exposing the neck.

Once you've chosen your preferred head-to-body ratio, be sure to allow room on your medium to draw the entire body. It's no fun to get to the foot and find you're out of room.

In Japanese animation and manga, the fingers are usually drawn open.

Notice how the feet are level with the plane of the ground and form a straight line.

While you are learning, try setting your character's head straight on the neck.

As you practice drawing perspective and seeing the boxes of the face, you will reach a point where you can skillfully draw your character at any angle. Just a little change here and there will have dramatic effect.

This leg is bent at the knee and at rest, and does not bear the figure's weight.

Weight is planted on the right foot.

There is no tension in the left leg in this pose.

To give the perception of depth, make an extreme purse. This is achieved nicely by the stark contrast between the length of the right and left legs.

Even when the character is at rest, it can be very expressive. Sometimes all it takes is the strategic placement of a foot or a few fingers.

Moving One Hand

Try moving just the hands. One hand on the waist or both clasped together can make a distinct impression.

With the arm hanging naturally, this pose resembles the letter "S" or "Z" as you can see by the bend of the waist. The more you emphasize the personality of the character, the more deformed the pose will become.

There are many variations to the hand on the hip pose. Please remember the position of the thumb so as not to point the hand in the wrong direction.

The left and right feet are perpendicular (in the shape of the letter "T"). This pose is used only for women.

Even if the arms are folded, if the chest juts out, your character will exude self-confidence.

Letting the right arm hang naturally and grasping it with the left hand behind the back is a feminine pose.

This character is not simply standing but has a some-what arched back. This is a very common pose in anime and manga.

The crossed legs give this girl a rather coy look.

Draw the obscu-red portion lightly in your rough sketch.

Whatever the pose, the purse and vanishing points will change along with the distance between the toes or the shoulders.

When looking at the entire silhouette, the character will seem more quiet and mature if the hands are obscured by any part of the body.

The left hand hangs naturally, while the right hand is extended toward the viewer. Even without any words, it looks as though the character is saying something.

This pose shows one arm clasping the elbow of the other while the neck is lowered, emphasizing a timid expression.

Take a moment to verify the positioning of the feet and face as you move your viewpoint to the side. Doing so will help you continue to improve.

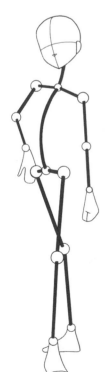
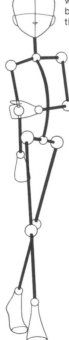
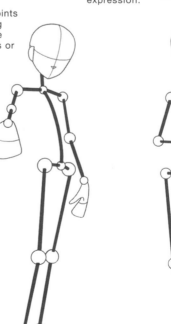
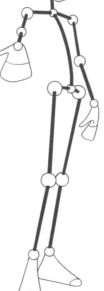
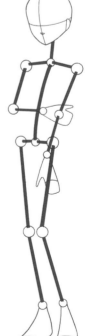

Try Moving Both Hands

When both hands are moved, you can really make your character perform. Even a single pose can send a powerful message.

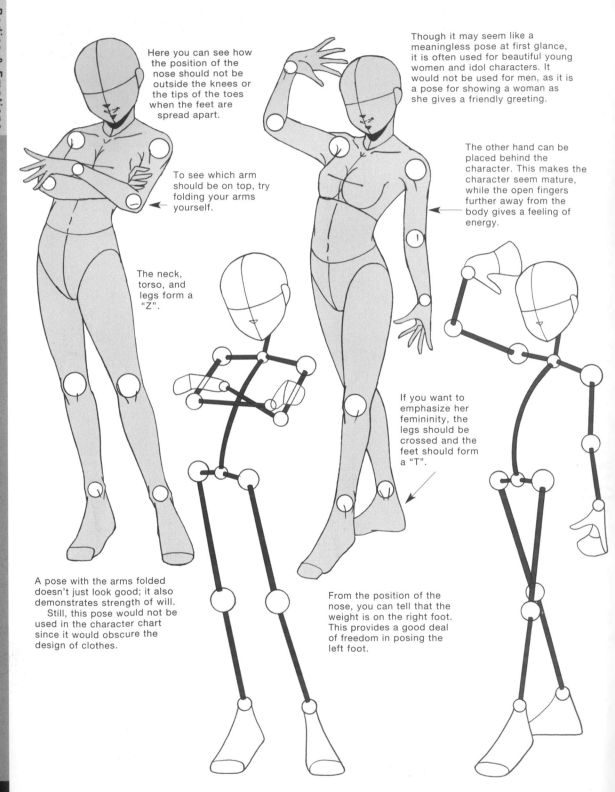

Here you can see how the position of the nose should not be outside the knees or the tips of the toes when the feet are spread apart.

To see which arm should be on top, try folding your arms yourself.

The neck, torso, and legs form a "Z".

A pose with the arms folded doesn't just look good; it also demonstrates strength of will.
 Still, this pose would not be used in the character chart since it would obscure the design of clothes.

Though it may seem like a meaningless pose at first glance, it is often used for beautiful young women and idol characters. It would not be used for men, as it is a pose for showing a woman as she gives a friendly greeting.

The other hand can be placed behind the character. This makes the character seem mature, while the open fingers further away from the body gives a feeling of energy.

If you want to emphasize her femininity, the legs should be crossed and the feet should form a "T".

From the position of the nose, you can tell that the weight is on the right foot. This provides a good deal of freedom in posing the left foot.

Try creating different poses for different sized characters to fit the world you have created.

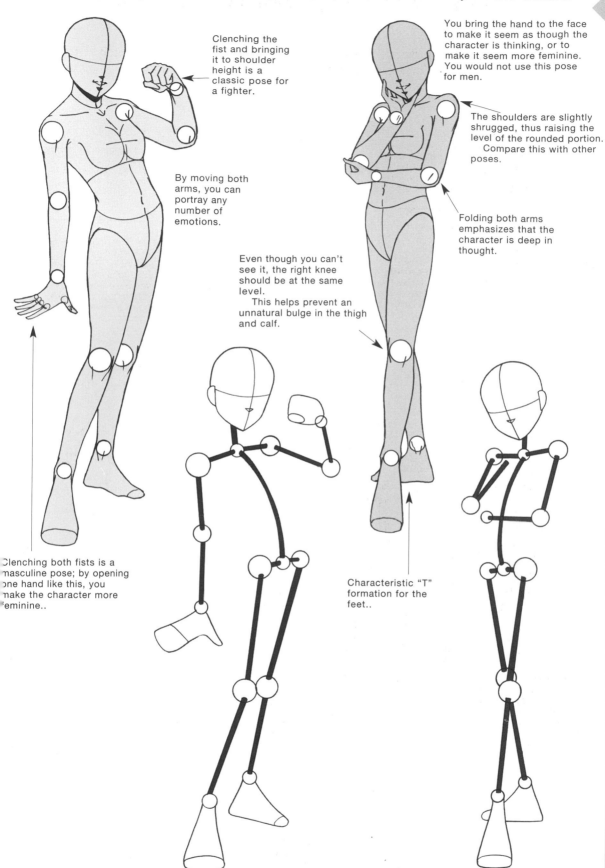

Clenching the fist and bringing it to shoulder height is a classic pose for a fighter.

By moving both arms, you can portray any number of emotions.

You bring the hand to the face to make it seem as though the character is thinking, or to make it seem more feminine. You would not use this pose for men.

The shoulders are slightly shrugged, thus raising the level of the rounded portion. Compare this with other poses.

Folding both arms emphasizes that the character is deep in thought.

Even though you can't see it, the right knee should be at the same level.
This helps prevent an unnatural bulge in the thigh and calf.

Clenching both fists is a masculine pose; by opening one hand like this, you make the character more feminine..

Characteristic "T" formation for the feet..

Hands On The Hips

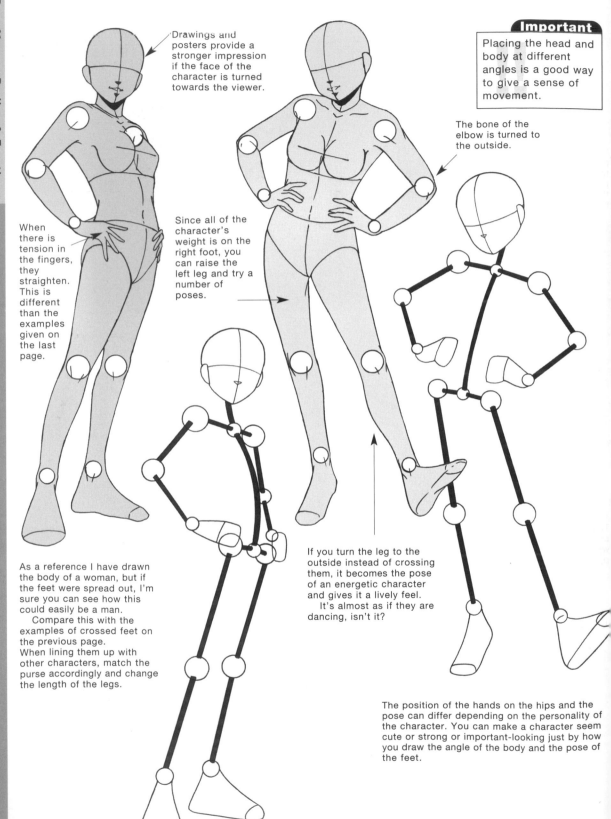

Drawings and posters provide a stronger impression if the face of the character is turned towards the viewer.

The bone of the elbow is turned to the outside.

When there is tension in the fingers, they straighten. This is different than the examples given on the last page.

Since all of the character's weight is on the right foot, you can raise the left leg and try a number of poses.

As a reference I have drawn the body of a woman, but if the feet were spread out, I'm sure you can see how this could easily be a man.

Compare this with the examples of crossed feet on the previous page.
When lining them up with other characters, match the purse accordingly and change the length of the legs.

If you turn the leg to the outside instead of crossing them, it becomes the pose of an energetic character and gives it a lively feel.
It's almost as if they are dancing, isn't it?

The position of the hands on the hips and the pose can differ depending on the personality of the character. You can make a character seem cute or strong or important-looking just by how you draw the angle of the body and the pose of the feet.

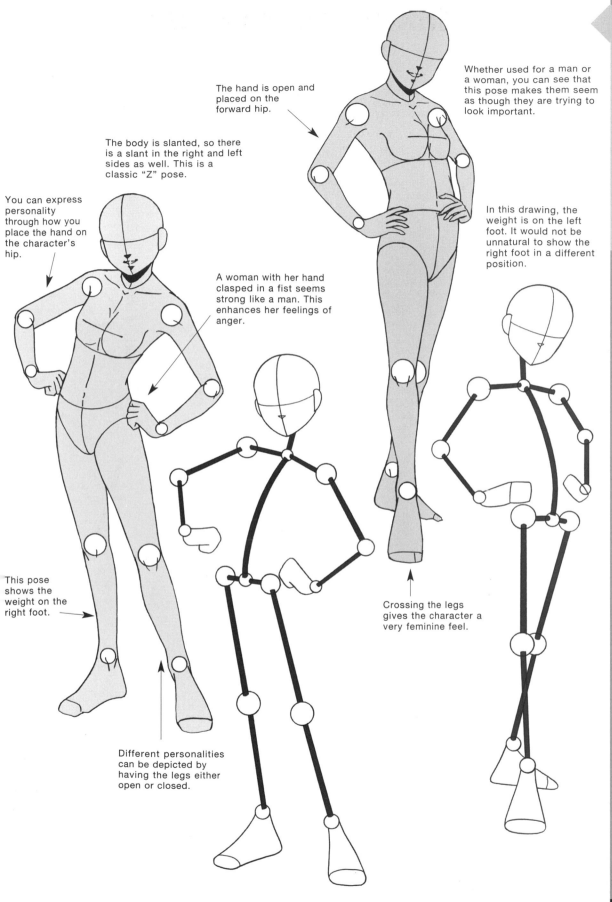

The hand is open and placed on the forward hip.

The body is slanted, so there is a slant in the right and left sides as well. This is a classic "Z" pose.

Whether used for a man or a woman, you can see that this pose makes them seem as though they are trying to look important.

You can express personality through how you place the hand on the character's hip.

A woman with her hand clasped in a fist seems strong like a man. This enhances her feelings of anger.

In this drawing, the weight is on the left foot. It would not be unnatural to show the right foot in a different position.

This pose shows the weight on the right foot.

Crossing the legs gives the character a very feminine feel.

Different personalities can be depicted by having the legs either open or closed.

Expressing Femininity

How do you express femininity? At the most basic level, it is no more than placing the hands at the same level, but the curve of the body is also important

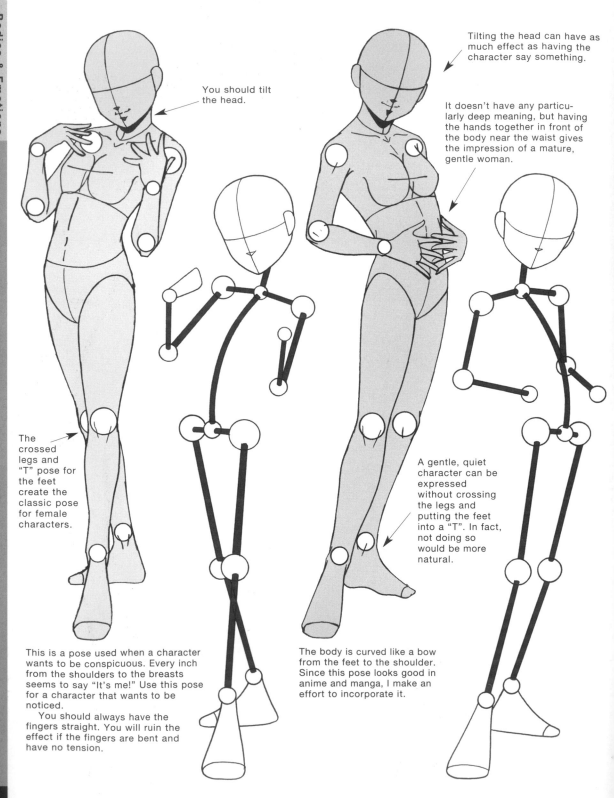

You should tilt the head.

Tilting the head can have as much effect as having the character say something.

It doesn't have any particularly deep meaning, but having the hands together in front of the body near the waist gives the impression of a mature, gentle woman.

The crossed legs and "T" pose for the feet create the classic pose for female characters.

A gentle, quiet character can be expressed without crossing the legs and putting the feet into a "T". In fact, not doing so would be more natural.

This is a pose used when a character wants to be conspicuous. Every inch from the shoulders to the breasts seems to say "It's me!" Use this pose for a character that wants to be noticed.

You should always have the fingers straight. You will ruin the effect if the fingers are bent and have no tension.

The body is curved like a bow from the feet to the shoulder. Since this pose looks good in anime and manga, I make an effort to incorporate it.

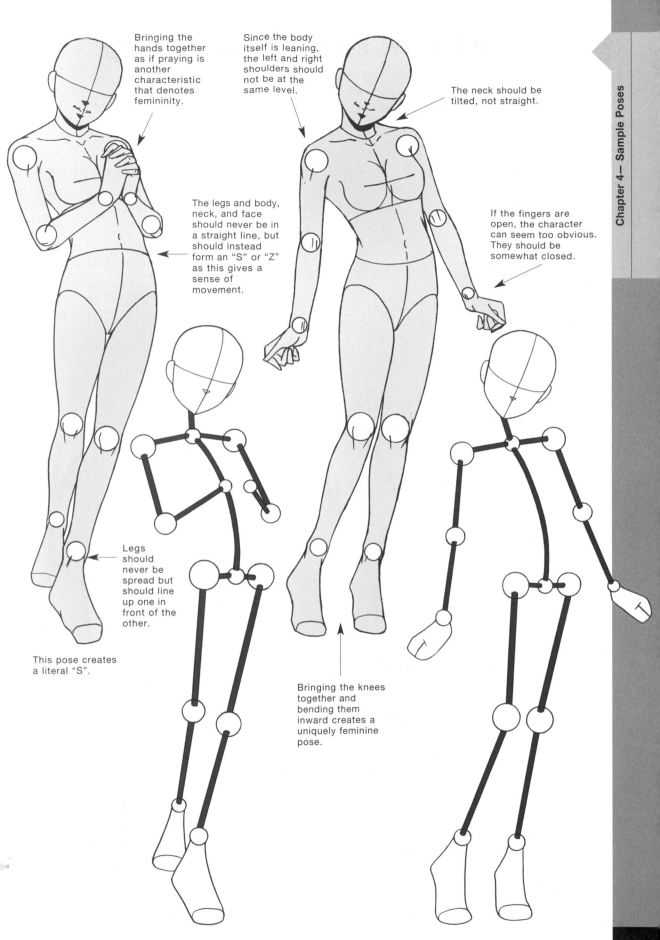

Bringing the hands together as if praying is another characteristic that denotes femininity.

Since the body itself is leaning, the left and right shoulders should not be at the same level.

The neck should be tilted, not straight.

The legs and body, neck, and face should never be in a straight line, but should instead form an "S" or "Z" as this gives a sense of movement.

If the fingers are open, the character can seem too obvious. They should be somewhat closed.

Legs should never be spread but should line up one in front of the other.

This pose creates a literal "S".

Bringing the knees together and bending them inward creates a uniquely feminine pose.

Posing To Express Unspoken Words

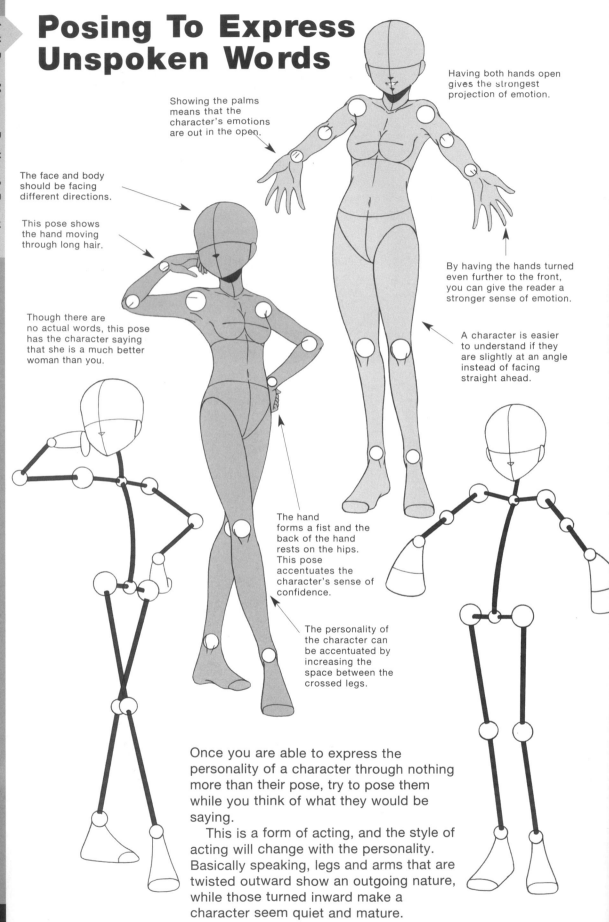

Having both hands open gives the strongest projection of emotion.

Showing the palms means that the character's emotions are out in the open.

The face and body should be facing different directions.

This pose shows the hand moving through long hair.

Though there are no actual words, this pose has the character saying that she is a much better woman than you.

By having the hands turned even further to the front, you can give the reader a stronger sense of emotion.

A character is easier to understand if they are slightly at an angle instead of facing straight ahead.

The hand forms a fist and the back of the hand rests on the hips. This pose accentuates the character's sense of confidence.

The personality of the character can be accentuated by increasing the space between the crossed legs.

Once you are able to express the personality of a character through nothing more than their pose, try to pose them while you think of what they would be saying.

This is a form of acting, and the style of acting will change with the personality. Basically speaking, legs and arms that are twisted outward show an outgoing nature, while those turned inward make a character seem quiet and mature.

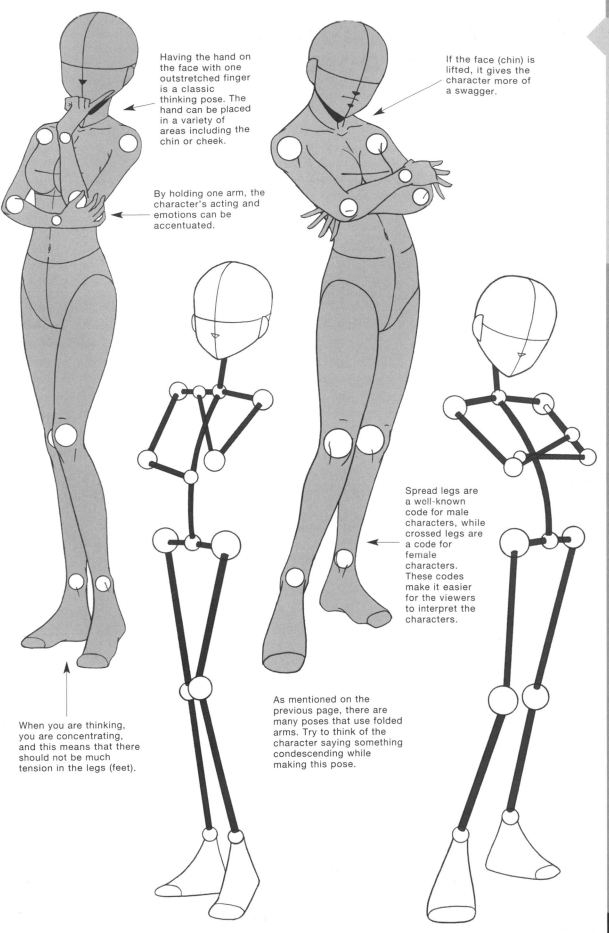

Having the hand on the face with one outstretched finger is a classic thinking pose. The hand can be placed in a variety of areas including the chin or cheek.

By holding one arm, the character's acting and emotions can be accentuated.

If the face (chin) is lifted, it gives the character more of a swagger.

Spread legs are a well-known code for male characters, while crossed legs are a code for female characters. These codes make it easier for the viewers to interpret the characters.

When you are thinking, you are concentrating, and this means that there should not be much tension in the legs (feet).

As mentioned on the previous page, there are many poses that use folded arms. Try to think of the character saying something condescending while making this pose.

Holding Props

If you come up with the plot from the beginning, it is easier to create poses where characters hold props such as weapons or a magic wand.

On the other hand, you can create characters and plots by experimenting with different poses through changing the types of weapons or items they carry. This is especially helpful when there are many characters that appear in the story.

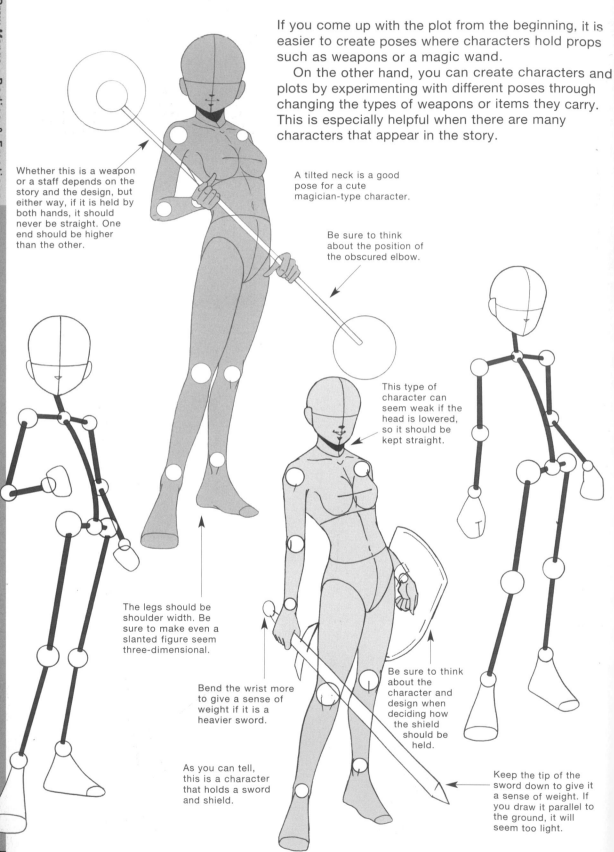

Whether this is a weapon or a staff depends on the story and the design, but either way, if it is held by both hands, it should never be straight. One end should be higher than the other.

A tilted neck is a good pose for a cute magician-type character.

Be sure to think about the position of the obscured elbow.

This type of character can seem weak if the head is lowered, so it should be kept straight.

The legs should be shoulder width. Be sure to make even a slanted figure seem three-dimensional.

Bend the wrist more to give a sense of weight if it is a heavier sword.

As you can tell, this is a character that holds a sword and shield.

Be sure to think about the character and design when deciding how the shield should be held.

Keep the tip of the sword down to give it a sense of weight. If you draw it parallel to the ground, it will seem too light.

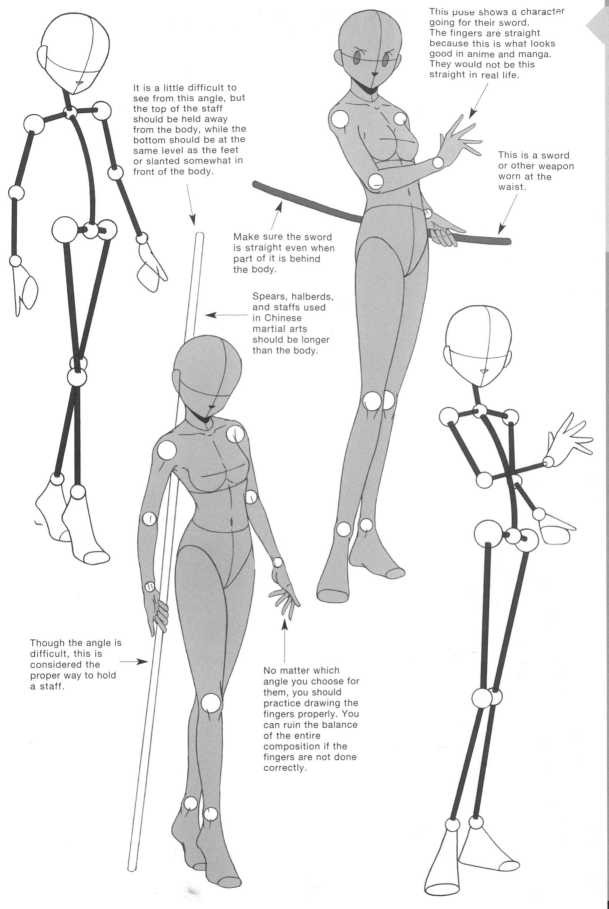

It is a little difficult to see from this angle, but the top of the staff should be held away from the body, while the bottom should be at the same level as the feet or slanted somewhat in front of the body.

This pose shows a character going for their sword. The fingers are straight because this is what looks good in anime and manga. They would not be this straight in real life.

This is a sword or other weapon worn at the waist.

Make sure the sword is straight even when part of it is behind the body.

Spears, halberds, and staffs used in Chinese martial arts should be longer than the body.

Though the angle is difficult, this is considered the proper way to hold a staff.

No matter which angle you choose for them, you should practice drawing the fingers properly. You can ruin the balance of the entire composition if the fingers are not done correctly.

Portray The Occupation Or Personality Through The Pose

It is easy to create a pose that shows a sword-wielding knight in fantasy story, a magician, or a fighter in high spirits.

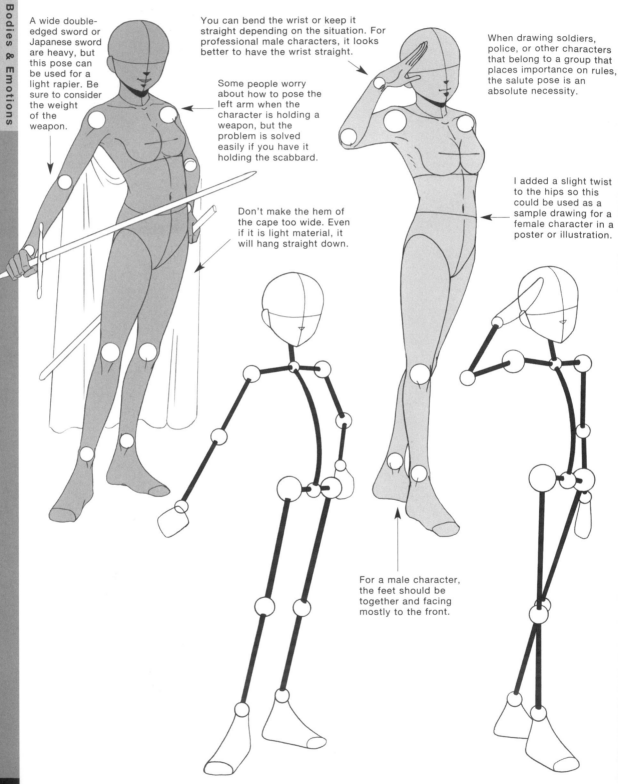

A wide double-edged sword or Japanese sword are heavy, but this pose can be used for a light rapier. Be sure to consider the weight of the weapon.

You can bend the wrist or keep it straight depending on the situation. For professional male characters, it looks better to have the wrist straight.

Some people worry about how to pose the left arm when the character is holding a weapon, but the problem is solved easily if you have it holding the scabbard.

Don't make the hem of the cape too wide. Even if it is light material, it will hang straight down.

When drawing soldiers, police, or other characters that belong to a group that places importance on rules, the salute pose is an absolute necessity.

I added a slight twist to the hips so this could be used as a sample drawing for a female character in a poster or illustration.

For a male character, the feet should be together and facing mostly to the front.

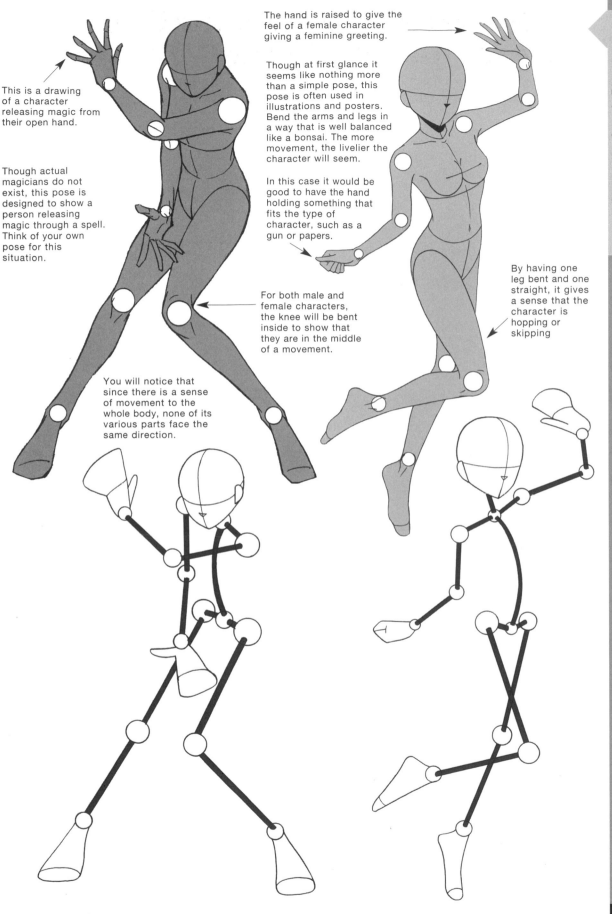

This is a drawing of a character releasing magic from their open hand.

Though actual magicians do not exist, this pose is designed to show a person releasing magic through a spell. Think of your own pose for this situation.

The hand is raised to give the feel of a female character giving a feminine greeting.

Though at first glance it seems like nothing more than a simple pose, this pose is often used in illustrations and posters. Bend the arms and legs in a way that is well balanced like a bonsai. The more movement, the livelier the character will seem.

In this case it would be good to have the hand holding something that fits the type of character, such as a gun or papers.

For both male and female characters, the knee will be bent inside to show that they are in the middle of a movement.

You will notice that since there is a sense of movement to the whole body, none of its various parts face the same direction.

By having one leg bent and one straight, it gives a sense that the character is hopping or skipping

Sitting In A Chair (1)

The main point when drawing a pose of a character sitting in a chair is to determine the level of the chair where the character is actually sitting and the ground on which they place their feet. You can either decide on the style of the chair and then draw the character appropriately to match it, or you can start with how the character will be sitting and match the chair. In anime and manga, you would usually start with the chair, but for illustrations you usually have a certain pose in mind and it becomes necessary to design the chair around that.

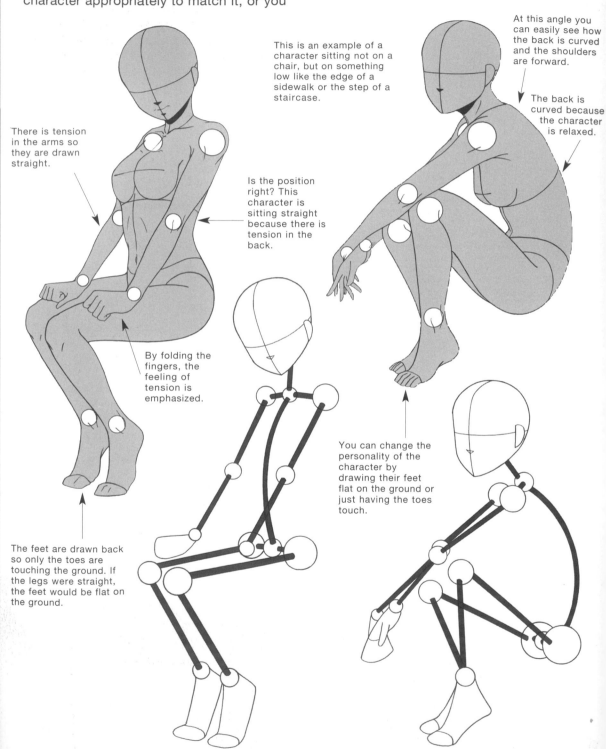

This is an example of a character sitting not on a chair, but on something low like the edge of a sidewalk or the step of a staircase.

There is tension in the arms so they are drawn straight.

Is the position right? This character is sitting straight because there is tension in the back.

By folding the fingers, the feeling of tension is emphasized.

At this angle you can easily see how the back is curved and the shoulders are forward.

The back is curved because the character is relaxed.

The feet are drawn back so only the toes are touching the ground. If the legs were straight, the feet would be flat on the ground.

You can change the personality of the character by drawing their feet flat on the ground or just having the toes touch.

Adding Movement To The Entire Body

Since the body is leaning, the height of the right and left shoulders is different.

You must have an idea of the dimensions of the surrounings if you want to draw the legs below the knees as being below the level at which the character is sitting.

Here the tips of the toes are actually touching the ground so either the toes or the ankles should be bent, but for the purpose of an illustration or poster, where design takes precedence, having the feet straight looks better.

Until this point we have only dealt with standing poses, but now let's move the entire body. Is it difficult? Not at all. The basics are the same as the standing poses. Not only that, but since you don't have to worry about where the weight is placed, it can be much easier. If you have mastered the square box, you will be just fine. Still, there is the question of how much you should bend each joint.

To get a feel of how these poses will look, try making them with your own body. Don't be shy. Even animators and manga artists do it.

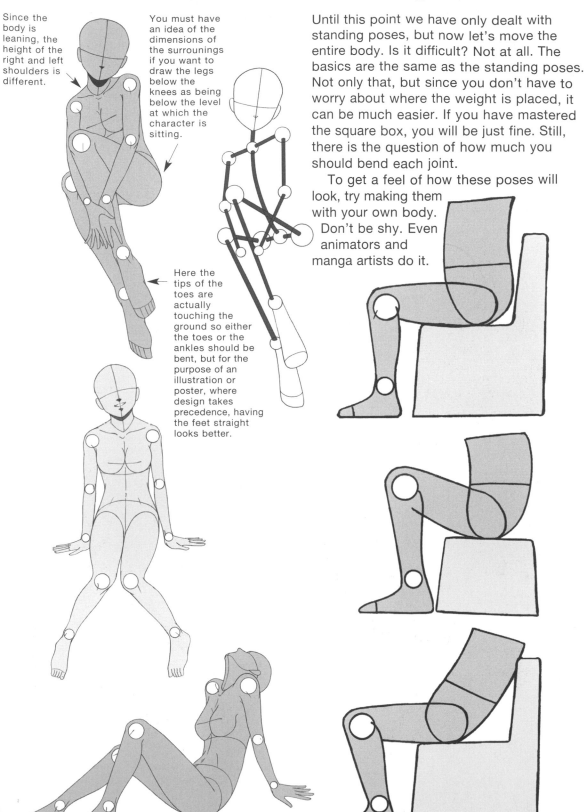

Sitting In A Chair (2)

Even when sitting in a chair, you have to express a character's personality and emotions. Try changing the angle and drawing the chair as well as the character.

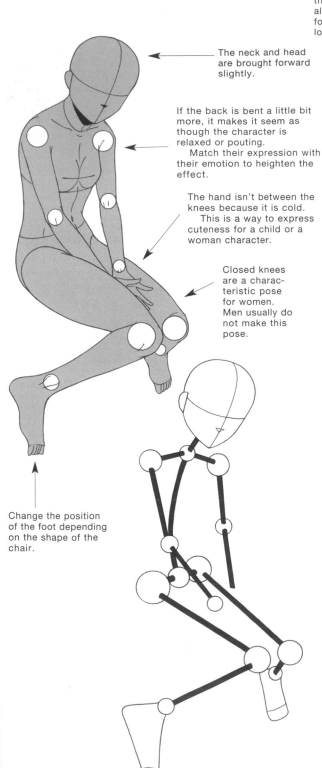

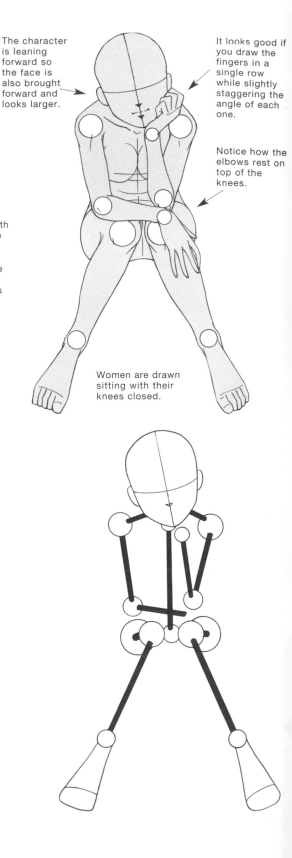

The character is leaning forward so the face is also brought forward and looks larger.

It looks good if you draw the fingers in a single row while slightly staggering the angle of each one.

The neck and head are brought forward slightly.

If the back is bent a little bit more, it makes it seem as though the character is relaxed or pouting.
Match their expression with their emotion to heighten the effect.

The hand isn't between the knees because it is cold.
This is a way to express cuteness for a child or a woman character.

Closed knees are a characteristic pose for women. Men usually do not make this pose.

Notice how the elbows rest on top of the knees.

Women are drawn sitting with their knees closed.

Change the position of the foot depending on the shape of the chair.

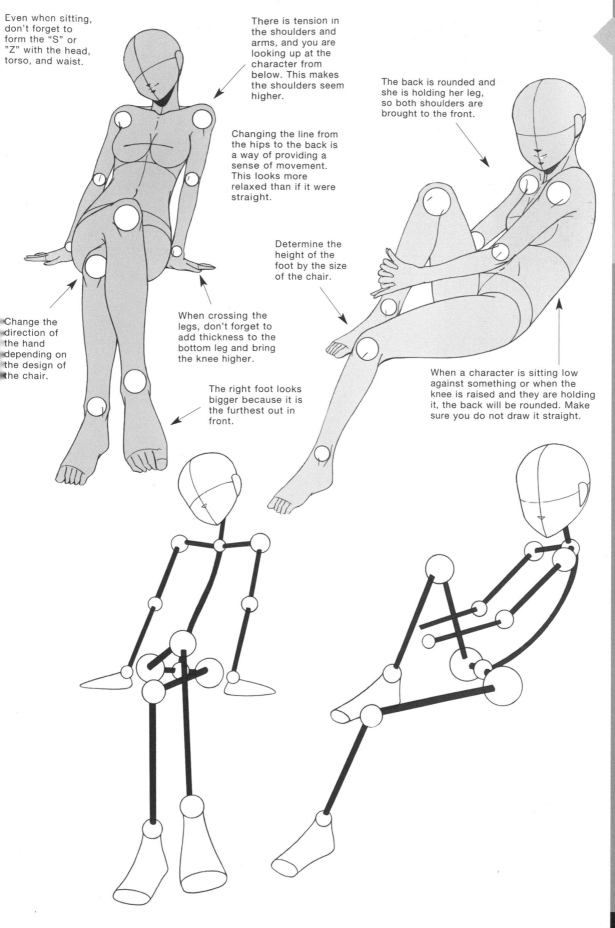

Even when sitting, don't forget to form the "S" or "Z" with the head, torso, and waist.

There is tension in the shoulders and arms, and you are looking up at the character from below. This makes the shoulders seem higher.

Changing the line from the hips to the back is a way of providing a sense of movement. This looks more relaxed than if it were straight.

The back is rounded and she is holding her leg, so both shoulders are brought to the front.

Determine the height of the foot by the size of the chair.

Change the direction of the hand depending on the design of the chair.

When crossing the legs, don't forget to add thickness to the bottom leg and bring the knee higher.

The right foot looks bigger because it is the furthest out in front.

When a character is sitting low against something or when the knee is raised and they are holding it, the back will be rounded. Make sure you do not draw it straight.

Sitting "Tai-iku" Style

The sitting pose shown below has a special name: "tai-iku". This name comes from the way students sit while holding their knees in gym class (tai-iku). While the term originated in manga and anime and was only used by otaku at first, it is now used in everyday Japanese as well.

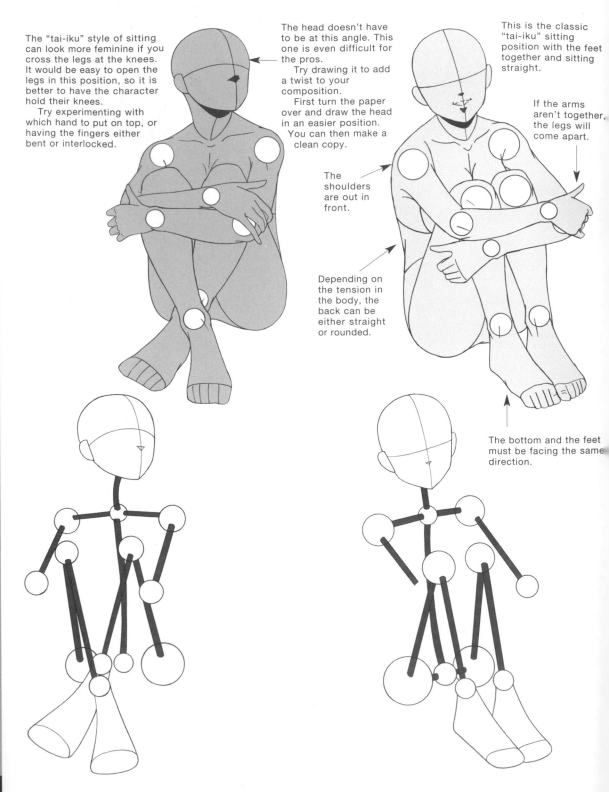

The "tai-iku" style of sitting can look more feminine if you cross the legs at the knees. It would be easy to open the legs in this position, so it is better to have the character hold their knees.

Try experimenting with which hand to put on top, or having the fingers either bent or interlocked.

The head doesn't have to be at this angle. This one is even difficult for the pros.

Try drawing it to add a twist to your composition.

First turn the paper over and draw the head in an easier position. You can then make a clean copy.

This is the classic "tai-iku" sitting position with the feet together and sitting straight.

If the arms aren't together, the legs will come apart.

The shoulders are out in front.

Depending on the tension in the body, the back can be either straight or rounded.

The bottom and the feet must be facing the same direction.

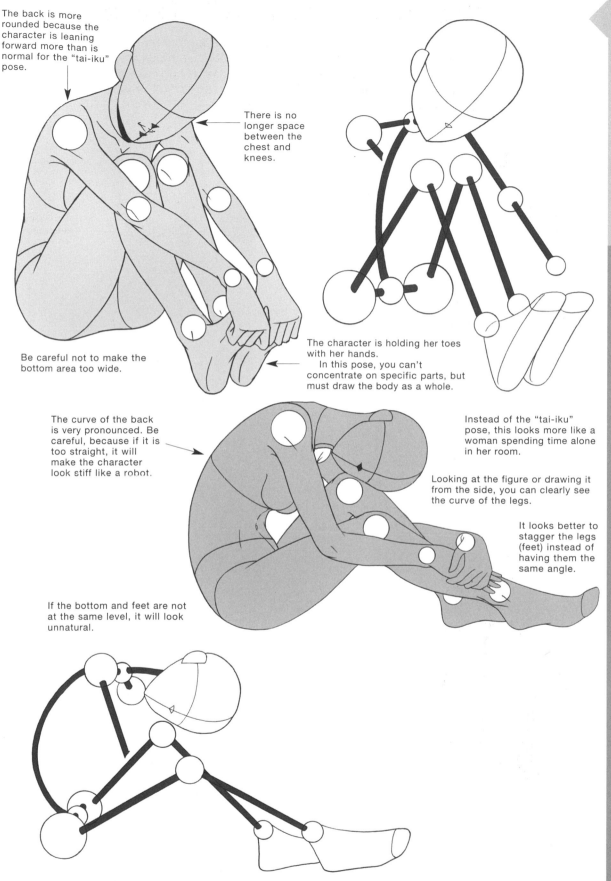

The back is more rounded because the character is leaning forward more than is normal for the "tai-iku" pose.

There is no longer space between the chest and knees.

Be careful not to make the bottom area too wide.

The character is holding her toes with her hands.
In this pose, you can't concentrate on specific parts, but must draw the body as a whole.

The curve of the back is very pronounced. Be careful, because if it is too straight, it will make the character look stiff like a robot.

Instead of the "tai-iku" pose, this looks more like a woman spending time alone in her room.

Looking at the figure or drawing it from the side, you can clearly see the curve of the legs.

It looks better to stagger the legs (feet) instead of having them the same angle.

If the bottom and feet are not at the same level, it will look unnatural.

"Woman Sitting" Pose

There is another unique type of sitting pose. It is called "woman sitting" and it shows a character sitting on their knees with their bottom flat on the ground. As the name suggests, a male character would not be drawn in this pose. It is used to express the femininity of the character

This pose will be used unfailingly in anime, games and manga that belong to the "bishojo" genre, and anyone drawing something in this genre should make sure to master it.

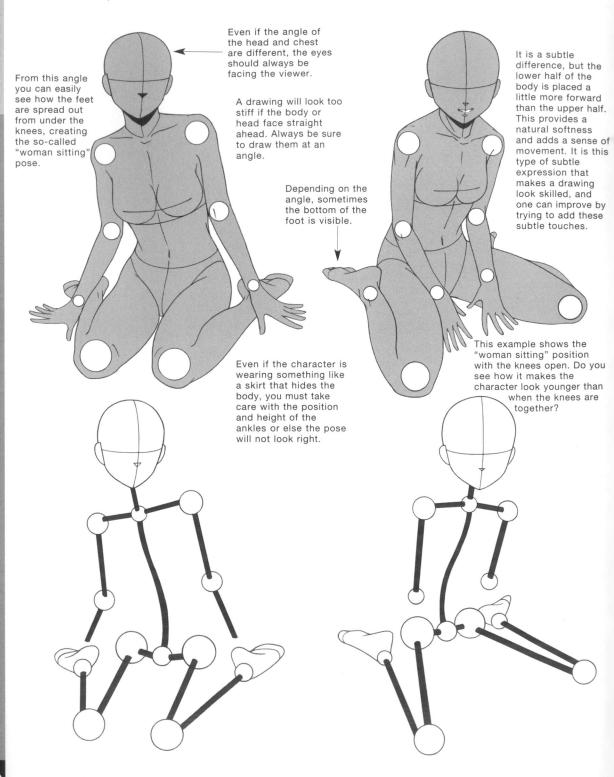

Even if the angle of the head and chest are different, the eyes should always be facing the viewer.

A drawing will look too stiff if the body or head face straight ahead. Always be sure to draw them at an angle.

Depending on the angle, sometimes the bottom of the foot is visible.

From this angle you can easily see how the feet are spread out from under the knees, creating the so-called "woman sitting" pose.

It is a subtle difference, but the lower half of the body is placed a little more forward than the upper half. This provides a natural softness and adds a sense of movement. It is this type of subtle expression that makes a drawing look skilled, and one can improve by trying to add these subtle touches.

Even if the character is wearing something like a skirt that hides the body, you must take care with the position and height of the ankles or else the pose will not look right.

This example shows the "woman sitting" position with the knees open. Do you see how it makes the character look younger than when the knees are together?

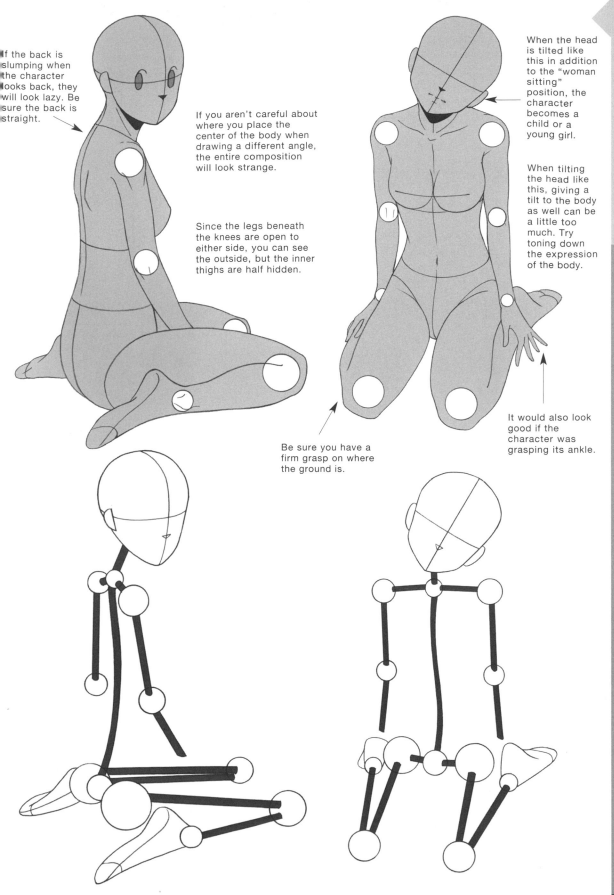

If the back is slumping when the character looks back, they will look lazy. Be sure the back is straight.

If you aren't careful about where you place the center of the body when drawing a different angle, the entire composition will look strange.

Since the legs beneath the knees are open to either side, you can see the outside, but the inner thighs are half hidden.

When the head is tilted like this in addition to the "woman sitting" position, the character becomes a child or a young girl.

When tilting the head like this, giving a tilt to the body as well can be a little too much. Try toning down the expression of the body.

Be sure you have a firm grasp on where the ground is.

It would also look good if the character was grasping its ankle.

Relaxing the Knees

The "woman sitting" position isn't the only pose for showing a woman sitting. While this position is mostly used for children, you can show women of all ages sitting by shifting the bottom to one side and having them relax off of their knees.

The line of the back changes depending on whether or not the hands are touching the ground.

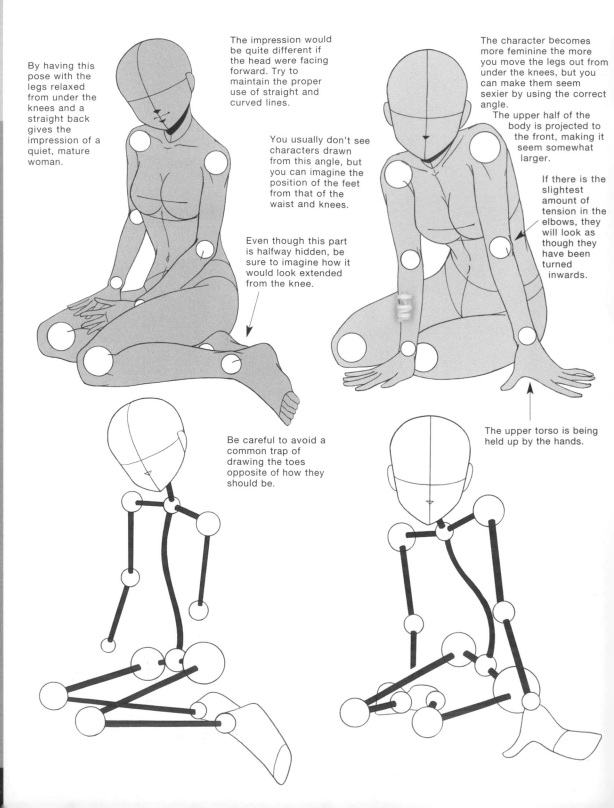

By having this pose with the legs relaxed from under the knees and a straight back gives the impression of a quiet, mature woman.

The impression would be quite different if the head were facing forward. Try to maintain the proper use of straight and curved lines.

You usually don't see characters drawn from this angle, but you can imagine the position of the feet from that of the waist and knees.

Even though this part is halfway hidden, be sure to imagine how it would look extended from the knee.

The character becomes more feminine the more you move the legs out from under the knees, but you can make them seem sexier by using the correct angle.

The upper half of the body is projected to the front, making it seem somewhat larger.

If there is the slightest amount of tension in the elbows, they will look as though they have been turned inwards.

The upper torso is being held up by the hands.

Be careful to avoid a common trap of drawing the toes opposite of how they should be.

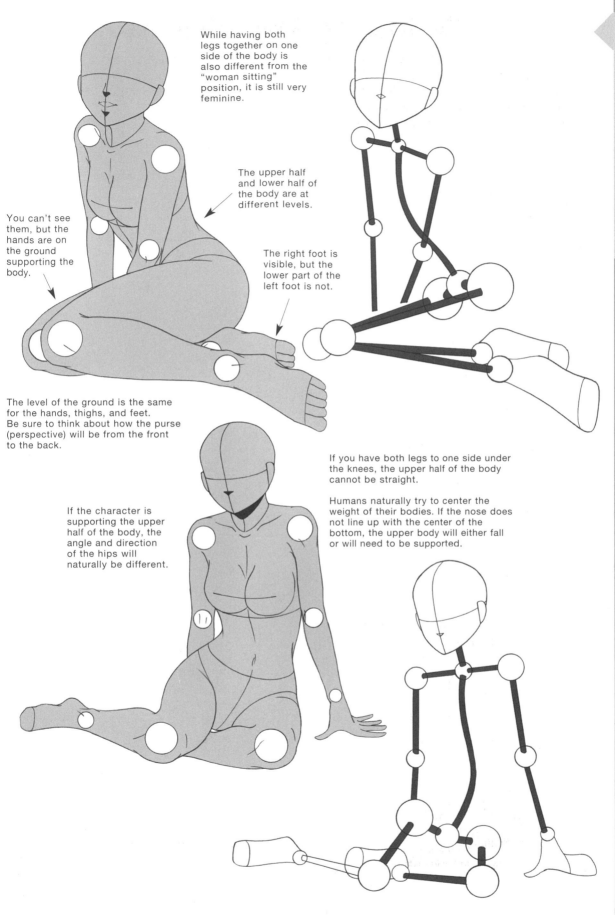

While having both legs together on one side of the body is also different from the "woman sitting" position, it is still very feminine.

You can't see them, but the hands are on the ground supporting the body.

The upper half and lower half of the body are at different levels.

The right foot is visible, but the lower part of the left foot is not.

The level of the ground is the same for the hands, thighs, and feet. Be sure to think about how the purse (perspective) will be from the front to the back.

If the character is supporting the upper half of the body, the angle and direction of the hips will naturally be different.

If you have both legs to one side under the knees, the upper half of the body cannot be straight.

Humans naturally try to center the weight of their bodies. If the nose does not line up with the center of the bottom, the upper body will either fall or will need to be supported.

Relaxed Sitting Position

Sitting with the legs separated or stretched out is sitting in a relaxed position.

This position looks more realistic if you don't curve the back too much or make it too straight.

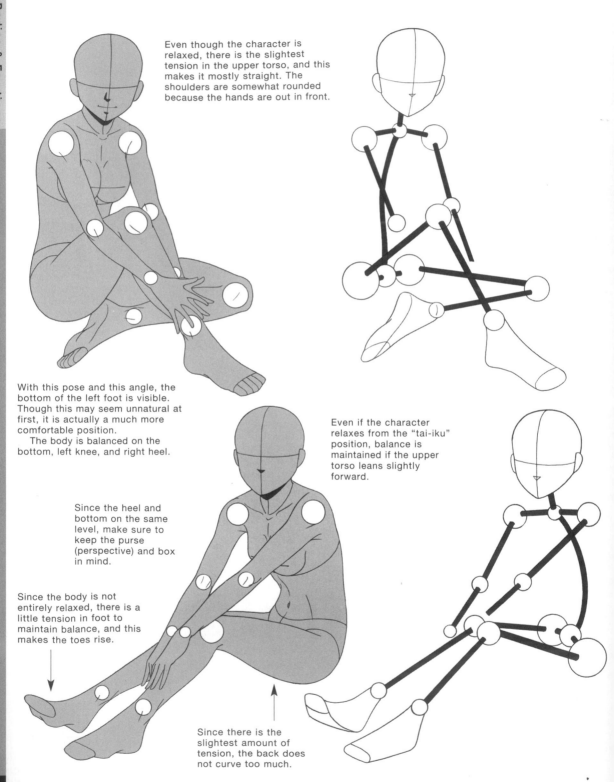

Even though the character is relaxed, there is the slightest tension in the upper torso, and this makes it mostly straight. The shoulders are somewhat rounded because the hands are out in front.

With this pose and this angle, the bottom of the left foot is visible. Though this may seem unnatural at first, it is actually a much more comfortable position.

The body is balanced on the bottom, left knee, and right heel.

Since the heel and bottom on the same level, make sure to keep the purse (perspective) and box in mind.

Since the body is not entirely relaxed, there is a little tension in foot to maintain balance, and this makes the toes rise.

Even if the character relaxes from the "tai-iku" position, balance is maintained if the upper torso leans slightly forward.

Since there is the slightest amount of tension, the back does not curve too much.

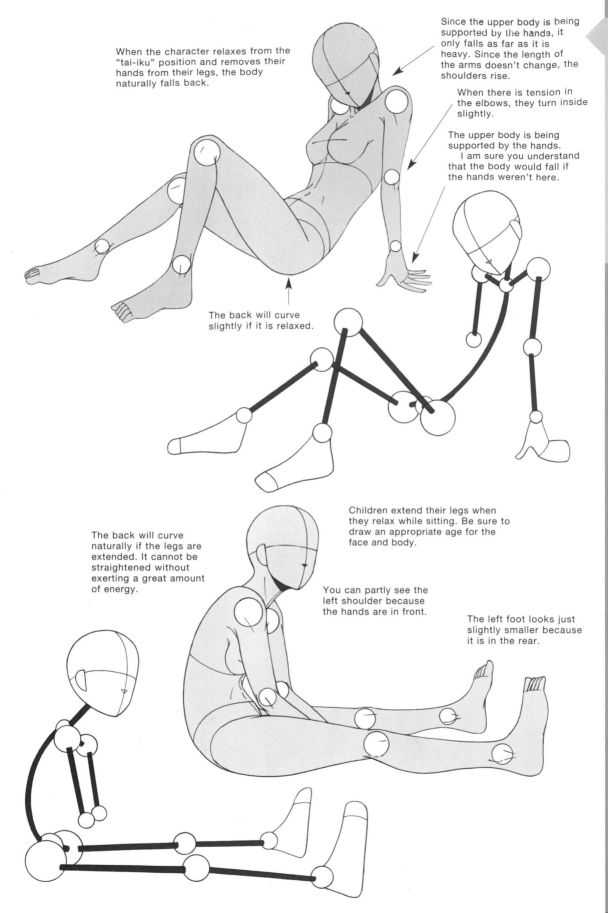

When the character relaxes from the "tai-iku" position and removes their hands from their legs, the body naturally falls back.

Since the upper body is being supported by the hands, it only falls as far as it is heavy. Since the length of the arms doesn't change, the shoulders rise.

When there is tension in the elbows, they turn inside slightly.

The upper body is being supported by the hands.
I am sure you understand that the body would fall if the hands weren't here.

The back will curve slightly if it is relaxed.

The back will curve naturally if the legs are extended. It cannot be straightened without exerting a great amount of energy.

Children extend their legs when they relax while sitting. Be sure to draw an appropriate age for the face and body.

You can partly see the left shoulder because the hands are in front.

The left foot looks just slightly smaller because it is in the rear.

Sitting With The Knees Together

Children and quiet characters, and, in special cases, characters that wear a Japanese kimono, sit with their knees together. Of course, this position can also be used with other characters, but it can be a very difficult pose to draw depending on the angle.

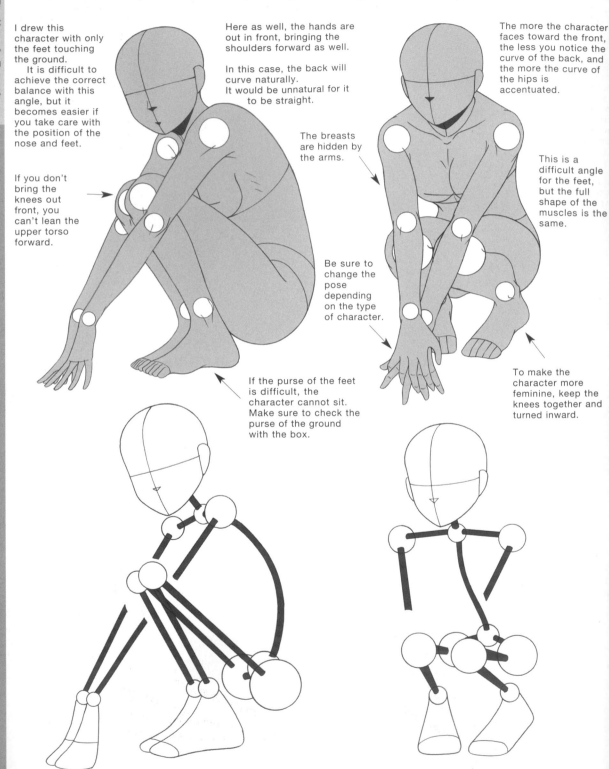

I drew this character with only the feet touching the ground.
It is difficult to achieve the correct balance with this angle, but it becomes easier if you take care with the position of the nose and feet.

If you don't bring the knees out front, you can't lean the upper torso forward.

Here as well, the hands are out in front, bringing the shoulders forward as well.

In this case, the back will curve naturally.
It would be unnatural for it to be straight.

The breasts are hidden by the arms.

Be sure to change the pose depending on the type of character.

If the purse of the feet is difficult, the character cannot sit. Make sure to check the purse of the ground with the box.

The more the character faces toward the front, the less you notice the curve of the back, and the more the curve of the hips is accentuated.

This is a difficult angle for the feet, but the full shape of the muscles is the same.

To make the character more feminine, keep the knees together and turned inward.

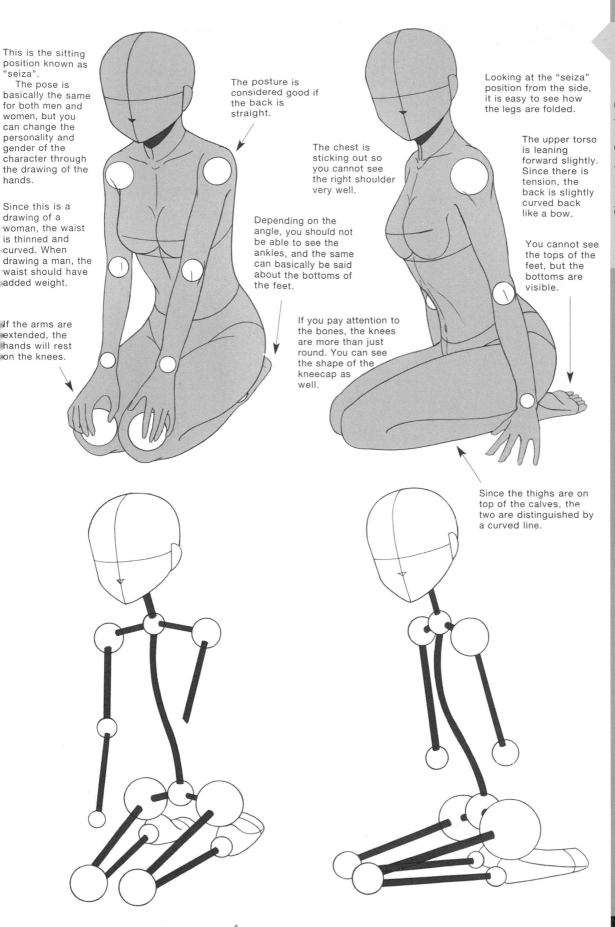

This is the sitting position known as "seiza".

The pose is basically the same for both men and women, but you can change the personality and gender of the character through the drawing of the hands.

Since this is a drawing of a woman, the waist is thinned and curved. When drawing a man, the waist should have added weight.

If the arms are extended, the hands will rest on the knees.

The posture is considered good if the back is straight.

The chest is sticking out so you cannot see the right shoulder very well.

Depending on the angle, you should not be able to see the ankles, and the same can basically be said about the bottoms of the feet.

If you pay attention to the bones, the knees are more than just round. You can see the shape of the kneecap as well.

Looking at the "seiza" position from the side, it is easy to see how the legs are folded.

The upper torso is leaning forward slightly. Since there is tension, the back is slightly curved back like a bow.

You cannot see the tops of the feet, but the bottoms are visible.

Since the thighs are on top of the calves, the two are distinguished by a curved line.

Other Varieties of Sitting Positions (1)

Having the character lean forward in addition to sitting can make them seem sexier or cuter. There are many different ways to adapt this technique. Creating a sexy pose by intentionally twisting the hips is a technique that is also used in Japanese anime and manga.

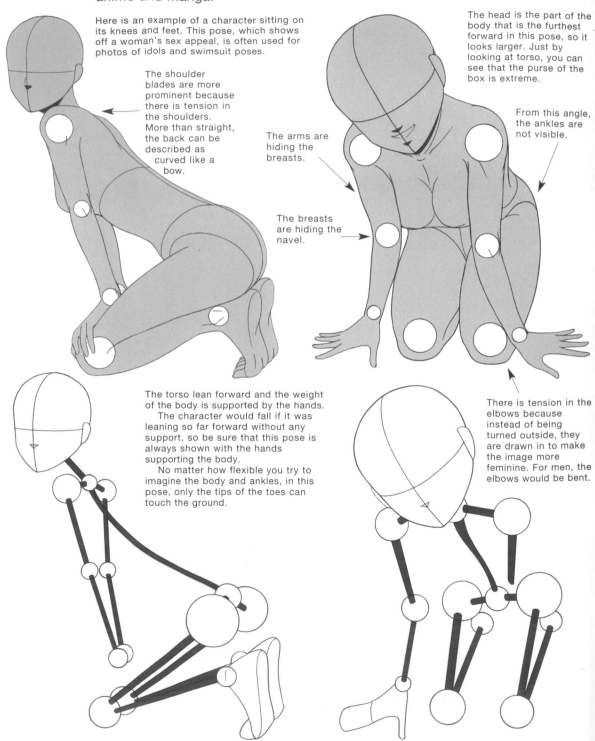

Here is an example of a character sitting on its knees and feet. This pose, which shows off a woman's sex appeal, is often used for photos of idols and swimsuit poses.

The shoulder blades are more prominent because there is tension in the shoulders. More than straight, the back can be described as curved like a bow.

The head is the part of the body that is the furthest forward in this pose, so it looks larger. Just by looking at torso, you can see that the purse of the box is extreme.

From this angle, the ankles are not visible.

The arms are hiding the breasts.

The breasts are hiding the navel.

The torso lean forward and the weight of the body is supported by the hands.

The character would fall if it was leaning so far forward without any support, so be sure that this pose is always shown with the hands supporting the body.

No matter how flexible you try to imagine the body and ankles, in this pose, only the tips of the toes can touch the ground.

There is tension in the elbows because instead of being turned outside, they are drawn in to make the image more feminine. For men, the elbows would be bent.

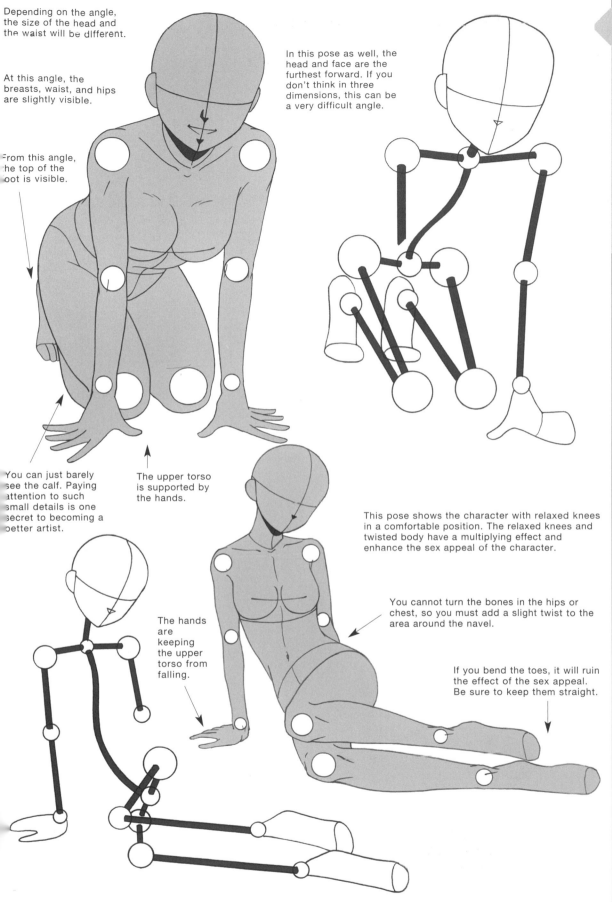

Depending on the angle, the size of the head and the waist will be different.

At this angle, the breasts, waist, and hips are slightly visible.

From this angle, the top of the foot is visible.

You can just barely see the calf. Paying attention to such small details is one secret to becoming a better artist.

The upper torso is supported by the hands.

In this pose as well, the head and face are the furthest forward. If you don't think in three dimensions, this can be a very difficult angle.

The hands are keeping the upper torso from falling.

This pose shows the character with relaxed knees in a comfortable position. The relaxed knees and twisted body have a multiplying effect and enhance the sex appeal of the character.

You cannot turn the bones in the hips or chest, so you must add a slight twist to the area around the navel.

If you bend the toes, it will ruin the effect of the sex appeal. Be sure to keep them straight.

Other Varieties of Poses (2)

The method for drawing sitting poses can differ depending on the angle. If the bottoms of the feet are facing front, then the feet will be larger and there will be a good sense of perspective.

Sitting cross-legged can be an interesting pose for both men and women. Because one of the feet is obscured, this position can be difficult to draw, and you should take care when deciding which foot will be on top and which will be on the bottom.

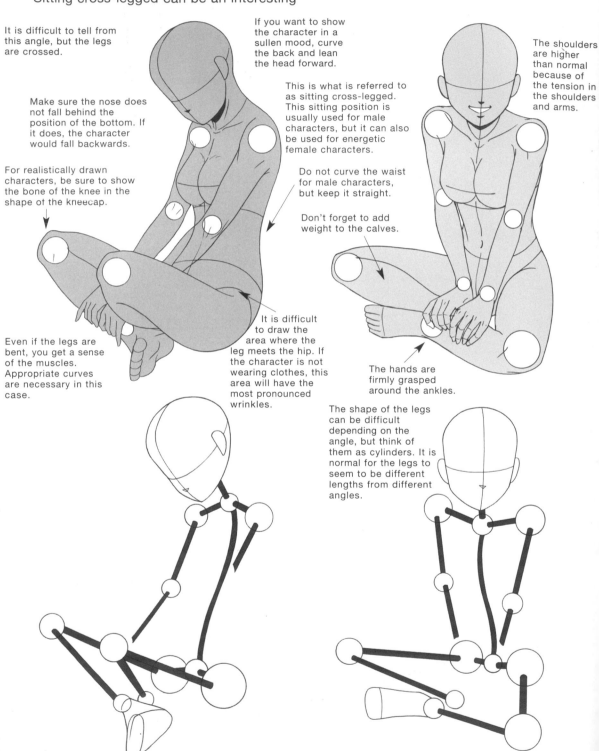

It is difficult to tell from this angle, but the legs are crossed.

Make sure the nose does not fall behind the position of the bottom. If it does, the character would fall backwards.

For realistically drawn characters, be sure to show the bone of the knee in the shape of the kneecap.

Even if the legs are bent, you get a sense of the muscles. Appropriate curves are necessary in this case.

If you want to show the character in a sullen mood, curve the back and lean the head forward.

This is what is referred to as sitting cross-legged. This sitting position is usually used for male characters, but it can also be used for energetic female characters.

Do not curve the waist for male characters, but keep it straight.

Don't forget to add weight to the calves.

It is difficult to draw the area where the leg meets the hip. If the character is not wearing clothes, this area will have the most pronounced wrinkles.

The shoulders are higher than normal because of the tension in the shoulders and arms.

The hands are firmly grasped around the ankles.

The shape of the legs can be difficult depending on the angle, but think of them as cylinders. It is normal for the legs to seem to be different lengths from different angles.

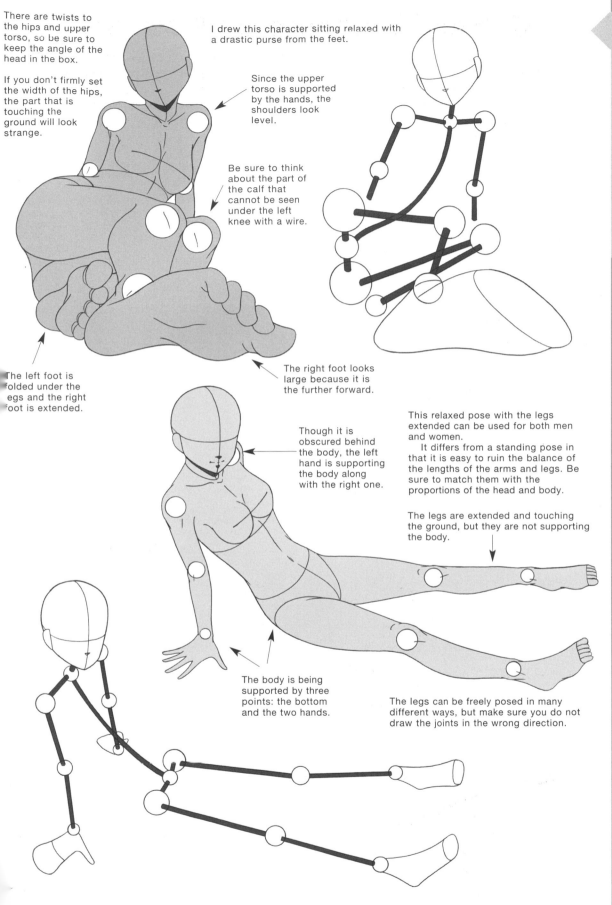

There are twists to the hips and upper torso, so be sure to keep the angle of the head in the box.

If you don't firmly set the width of the hips, the part that is touching the ground will look strange.

I drew this character sitting relaxed with a drastic purse from the feet.

Since the upper torso is supported by the hands, the shoulders look level.

Be sure to think about the part of the calf that cannot be seen under the left knee with a wire.

The left foot is folded under the legs and the right foot is extended.

The right foot looks large because it is the further forward.

Though it is obscured behind the body, the left hand is supporting the body along with the right one.

This relaxed pose with the legs extended can be used for both men and women.
　It differs from a standing pose in that it is easy to ruin the balance of the lengths of the arms and legs. Be sure to match them with the proportions of the head and body.

The legs are extended and touching the ground, but they are not supporting the body.

The body is being supported by three points: the bottom and the two hands.

The legs can be freely posed in many different ways, but make sure you do not draw the joints in the wrong direction.

Lying Down

Though you do not have to pay as much attention to the position of the legs as you would with standing poses, you do have to pay attention to the purse.

Be sure to draw the character while paying attention to the purse and square box between the waist and hips.

From this angle, if you bend the feet, the bottoms of the feet come into view naturally.

It is difficult to calculate the proportions of head and body when drawing a character that is lying down.

It will be easier if you determine the three dimensions with a box.

Sometimes the legs are obscured.

The elbow is stationary, but the hand can be moved freely.

The upper body is being supported by the elbows.

The entire stomach is flat on the ground, but there is roundness to the torso because some of it is not touching the ground itself. Be sure to add curves to the lines of the waist.

This area can also be handled with a belt or the lower hem of a shirt.

If the character is lying down, it is easy to balance the entire figure. You can change the angle a little to emphasize the perspective. Be sure to draw a line so you know where the spine is.

There is a slight bulge to the shoulder blades.

As with standing poses, crossing the legs gives the pose a more feminine feel.

When lying somewhere soft like a bed, the body will sink where weight is placed.

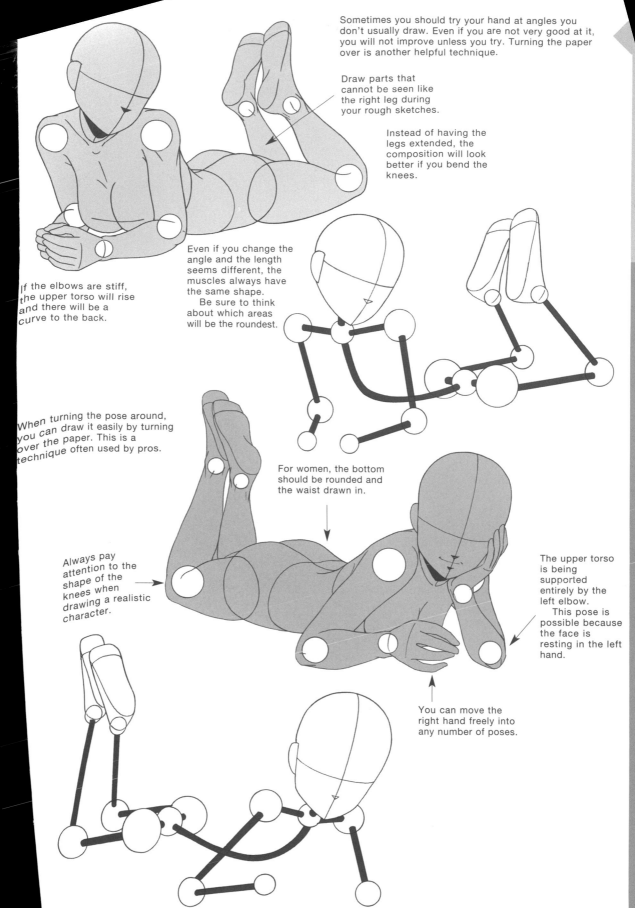

Sometimes you should try your hand at angles you don't usually draw. Even if you are not very good at it, you will not improve unless you try. Turning the paper over is another helpful technique.

Draw parts that cannot be seen like the right leg during your rough sketches.

Instead of having the legs extended, the composition will look better if you bend the knees.

If the elbows are stiff, the upper torso will rise and there will be a curve to the back.

Even if you change the angle and the length seems different, the muscles always have the same shape.
Be sure to think about which areas will be the roundest.

When turning the pose around, you can draw it easily by turning over the paper. This is a technique often used by pros.

For women, the bottom should be rounded and the waist drawn in.

Always pay attention to the shape of the knees when drawing a realistic character.

The upper torso is being supported entirely by the left elbow.
This pose is possible because the face is resting in the left hand.

You can move the right hand freely into any number of poses.

Think More of Fashion Than Costumes

One problem, or one worry, when drawing anime is clothes. While it is fine to design clothes based on the overall design of the character, in some older anime that were made on tight budgets and schedules, the characters wore the same costumes in both winter and summer. When snow began to fall, it really looked strange.

The situation has improved somewhat, but costumes are still rather simple and subdued. Why is this?

The answer lies in the fact that animators and manga artists are not very interested in fashion. I hope that young people who enter the industry will bring a new approach to character design. For instance, among hip-hop characters, a stadium jacket can be worn in many different ways.

Even when drawing these two characters in the manga style, the rough drawings and silhouettes are entirely different. More attention must be paid to character fashion in order to create new anime and manga.

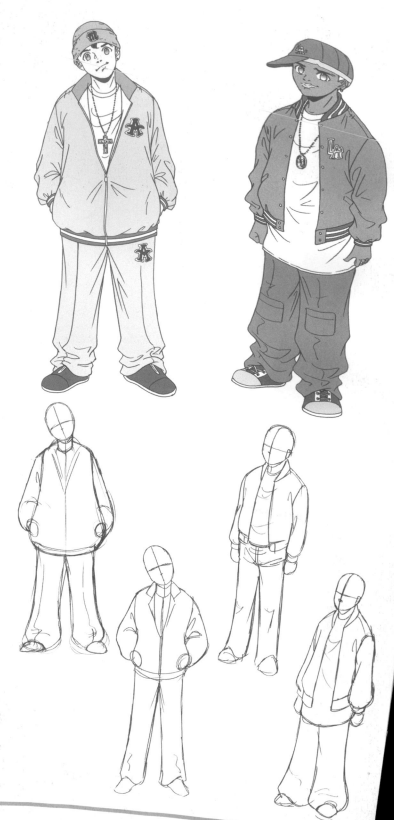

Chapter 5
Examples of Actual Character Types

Male Characters (1)

Most manga have men as their protagonists, but you should design your protagonist to appeal to the age and generation of viewers that is your target audience. This is because you want the viewers to empathize with the character: if he worries, you want them to worry; if he loses, you want them to be sad as well.

Also, a good-looking character is necessary to gain the readership of women. Do not forget to add normal characters like you would encounter in everyday life, since they will make the protagonist and good-looking character more believable.

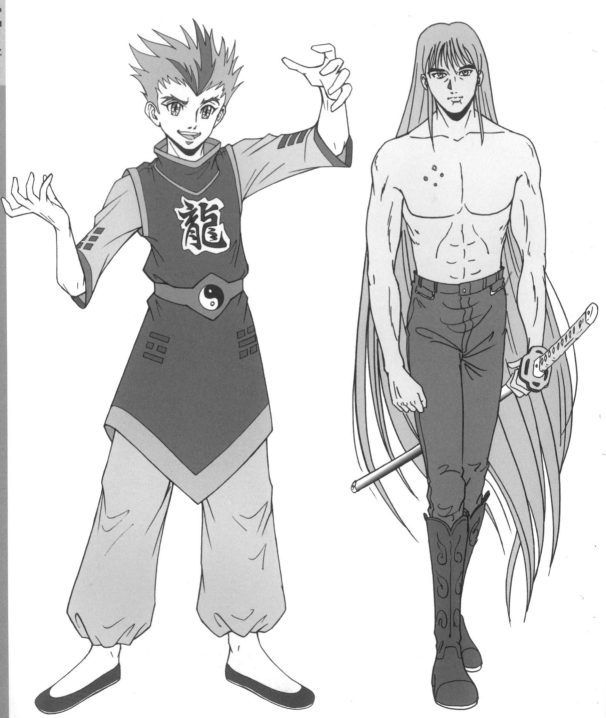

Male Characters (2)

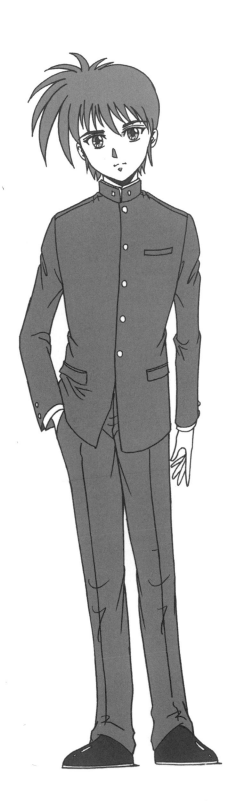

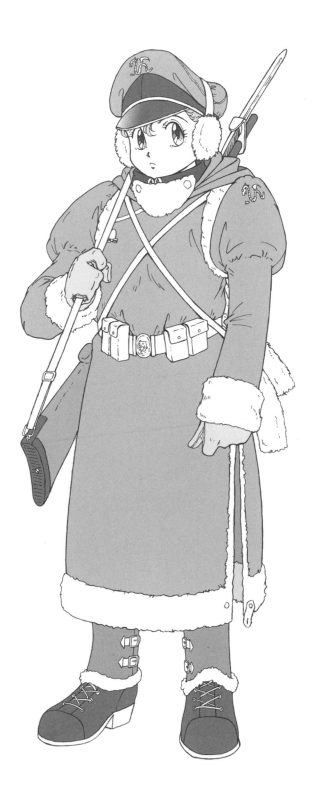

Warrior Characters (1)

Warrior characters come to life through the design of their weapons, armor, and uniforms. The design will differ depending on the era and country.

You should practice by copying drawings from fictitious works and studying history texts.

It can also be good to go to a museum. It is difficult even for pros to come up with designs starting from nothing, and that is why we will often look for reference books at bookstores even if we do not plan to use them right away.

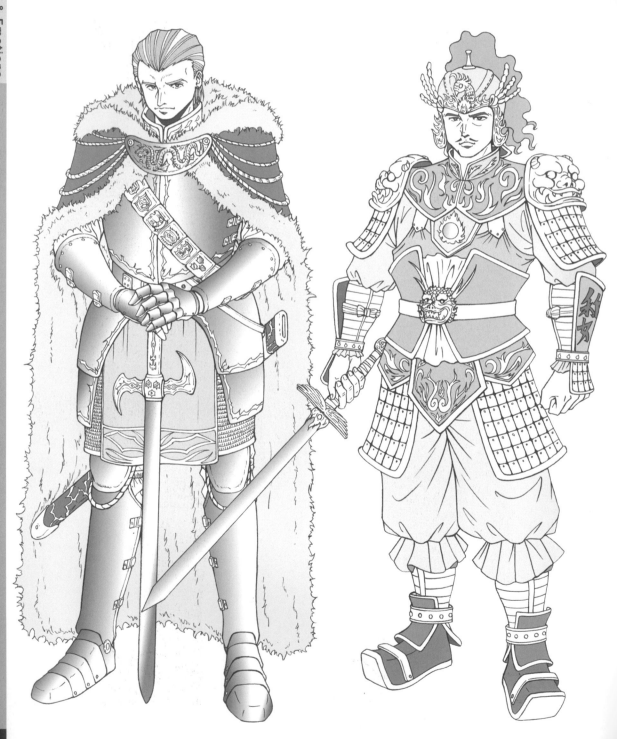

Warrior Characters (2)

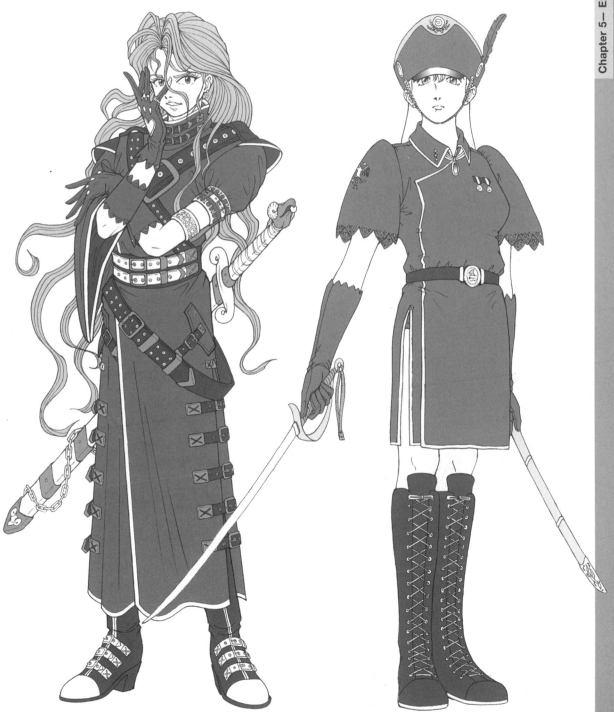

Female Characters (1)

There are ebbs and flows in the fads of how female characters are drawn, making it impossible to say which one is best. Still, even though the design of characters may change, the poses themselves do not, and this is why it is important to memorize feminine poses.

Cuteness and beauty are in the eye of the beholder, but anime and manga are drawn to appeal to a wide audience. Whether they have long hair or short, be sure to match the style with the personality and type of character.

Female Characters (2)

Characters in Comedies (1)

Let's Draw Manga— Bodies & Emotions

It is hard to go wrong with characters in comical works if you draw them from about 3 to 5 head-to-body size. There can be some unclear elements, such as how the costumes look compared with their large heads, but I leave the overall effect to the atmosphere of the piece and make sure the characters are cute. Directors can worry about whether to make the hands and feet larger or smaller, but usually the feet should be made larger to balance out the heads.

Characters in Comedies (2)

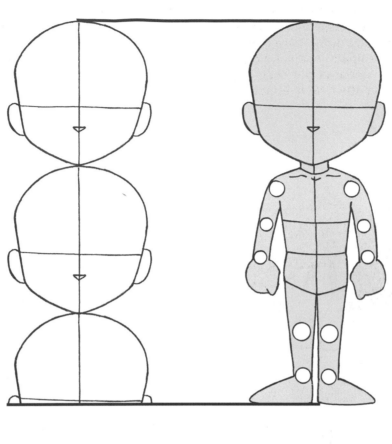

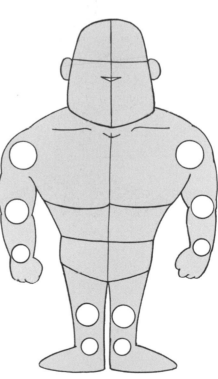

Characters in Comedies (3)

In comical works, there are rarely any characters that are entirely evil. They may get in the way of the protagonist, but it is hard to hate them. Even the villain sorcerer may seem like someone you know.

There are times when the protagonist's rival is a somewhat older woman, but she is usually scatterbrained and always fails.

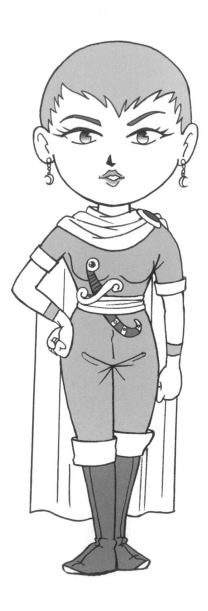

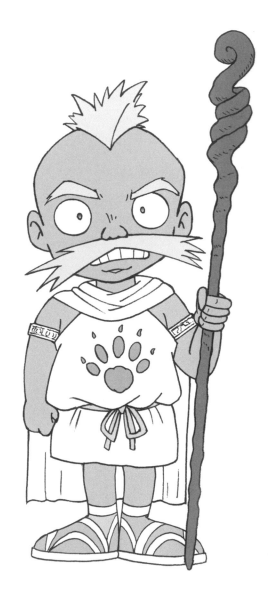

Characters in Comedies (4)

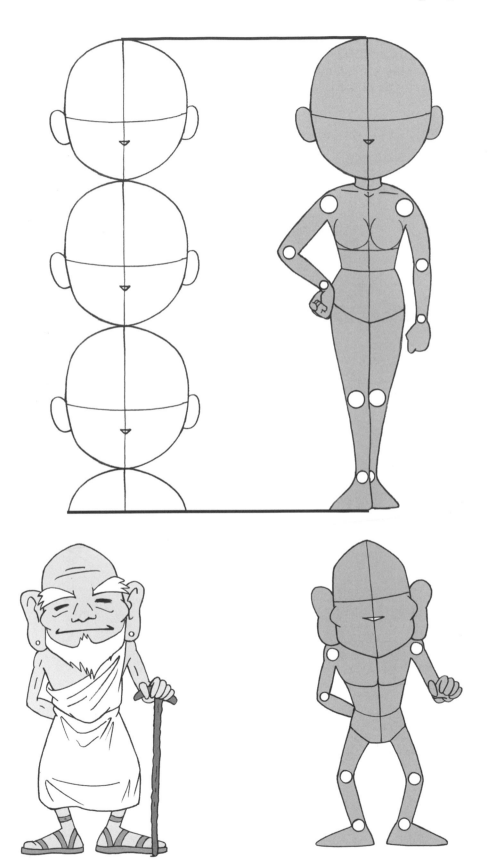

Older Female Characters

Older female characters appear in manga more than you would think. An older goddess is more convincing that a young woman. When you are unsure of where to take the story, you can conveniently use a village elder, the grandmother of the protagonist, or even a maid to create a new development.

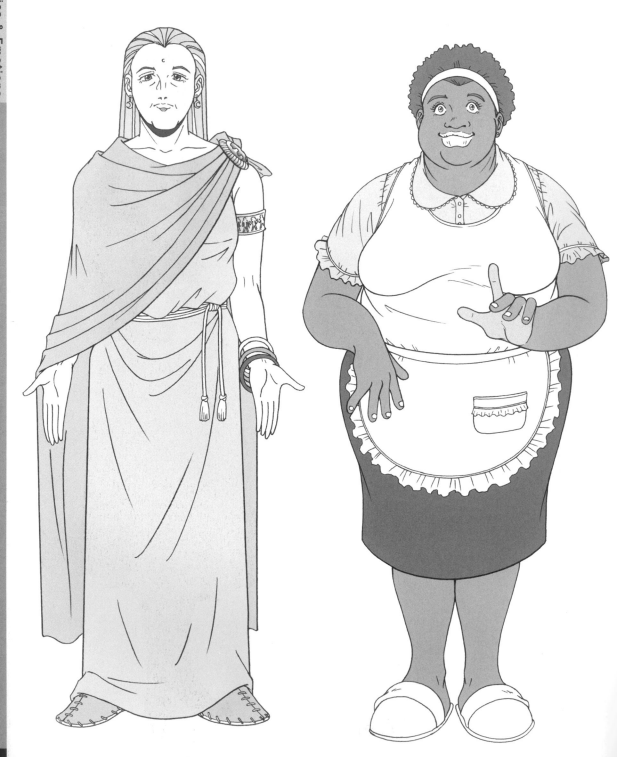

Older Female Characters

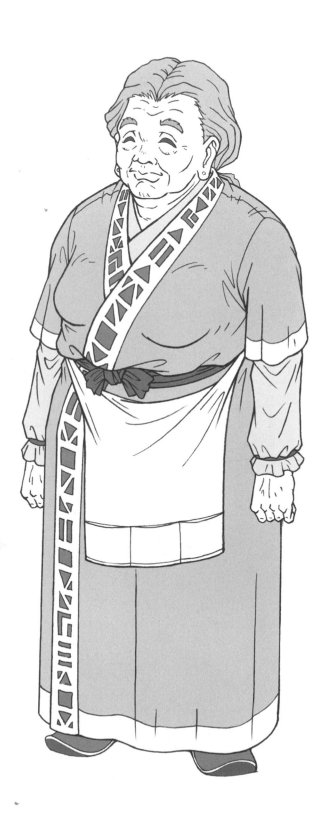

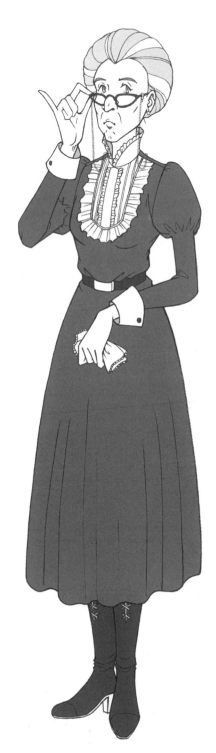

Older Male Characters

In addition to wrinkled faces, you can effectively portray older men with beards, slight slouches, and faces that project wisdom.

When creating a manga or anime, I like to have contrasting characters: good and evil, allies and villains. It is the same as creating a protagonist and his greatest enemy--it is easier to create an overall design with contrasting characters, and it makes the work easier to understand.

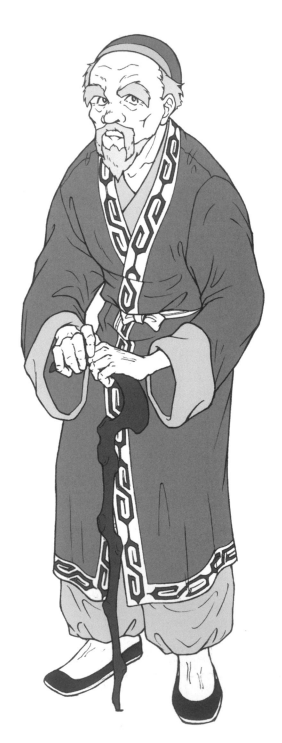

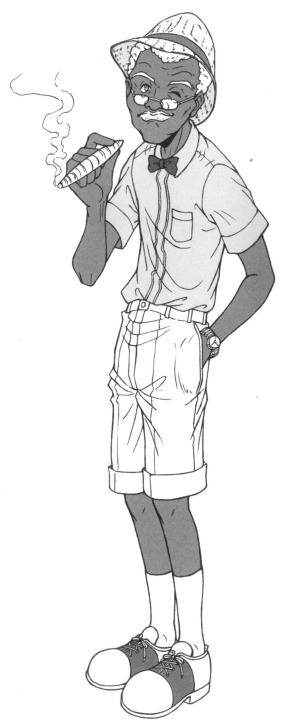

Older Male Characters

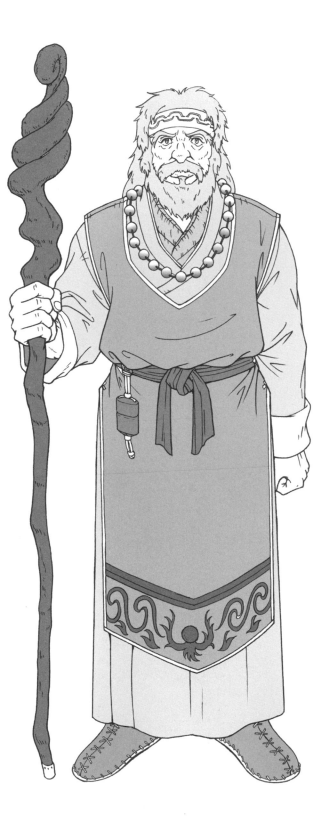

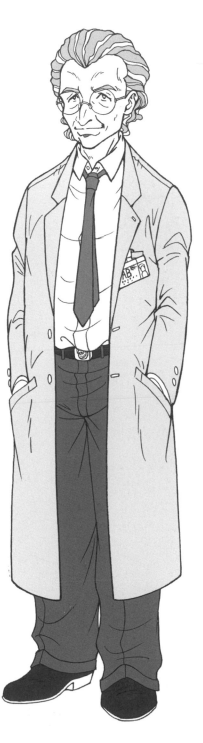

Older Male Villains

Villains must be recognizable as evil or the protagonist's enemy at first glance. They should have a piercing gaze, but there is more to this than raising the outer corner of the eyes. The eyes should be smaller, and they should constantly be glaring at others.

Also, they should be made to look stronger than the protagonist by making them taller and more muscular, for example. If they were smaller than the protagonist, the battle would be over immediately, and this would not make for a good story. Stories are interesting when you (the protagonist) are able to defeat someone stronger after a great struggle.

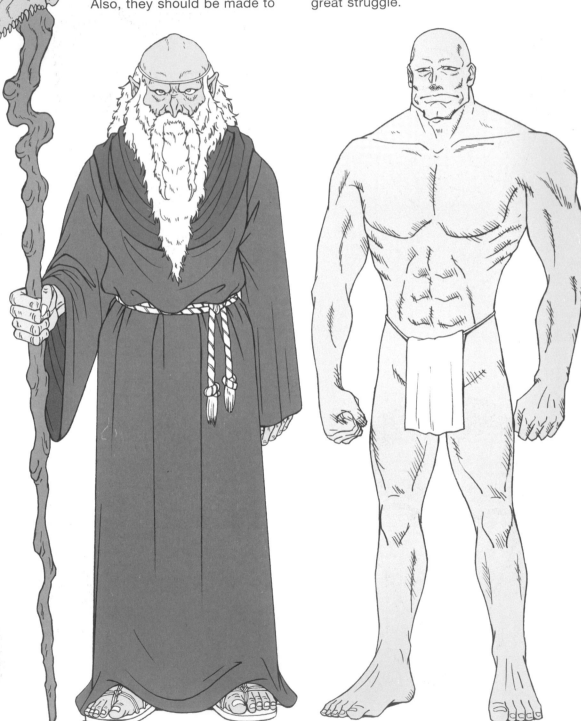

Older Male Villains

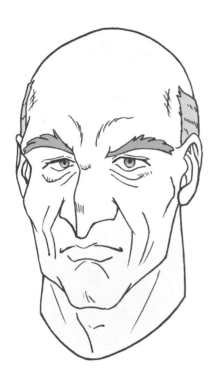

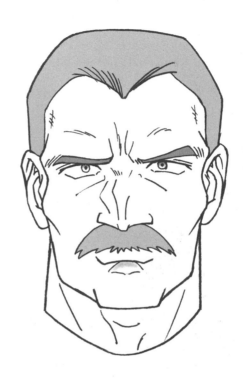

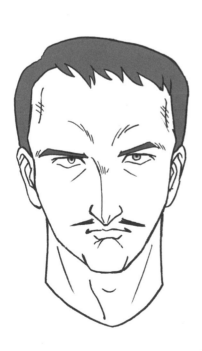

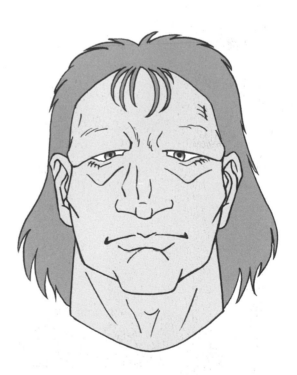

Drawing Distinctions (1)

Anime, manga and video games are filled with many different types of characters. In addition to classifying them simply as "good" and "bad" characters, their design will differ depending on their profession, and their costume will differ depending on their culture, civilization and religion.

Even in a detail as simple as an older man wearing a suit, there will be a big difference in the image he presents depending on whether he is wearing a single-breasted or double-breasted suit. Or, the impression the suit leaves may influence how you design the character.

The most important point is that you should be able to draw different types of suits.

It isn't necessary to study how to design difficult types of clothing.

Take the opportunity to look at the types of clothing people around you are wearing and what form they take.

For instance, if you wanted to make a distinction between a president and a prime minister, you could do so by having one wear a single-breasted suit and the other wear a double-breasted one.

Compare the differences in the suit designs on these two pages.

President

For the sake of argument, I have drawn him in a single-breasted suit, and made him a younger, energetic man. The buttons of his suit form a single row

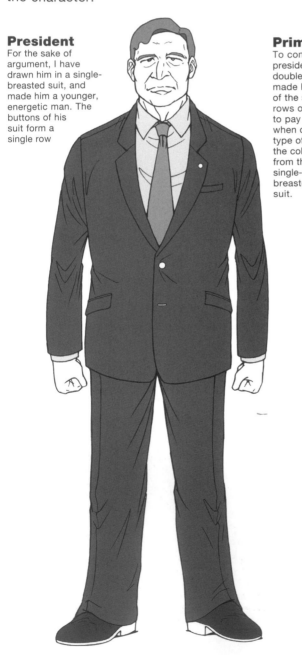

Prime Minister

To contrast him with the president, I drew him in a double-breasted suit and made him older. As the name of the suit implies, it has two rows of buttons. Be sure to pay attention when drawing this type of suit since the collar differs from that of a single-breasted suit.

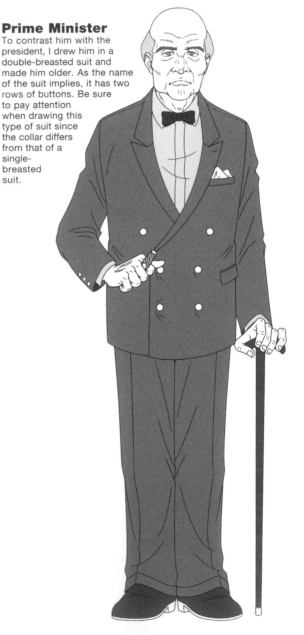

Drawing Distinctions (2)

Of course you can also draw distinctions between characters by making them good or bad, smart or not so much. You should be able to tell the difference between the gangster boss and the presidential aide with nothing more than a glance.

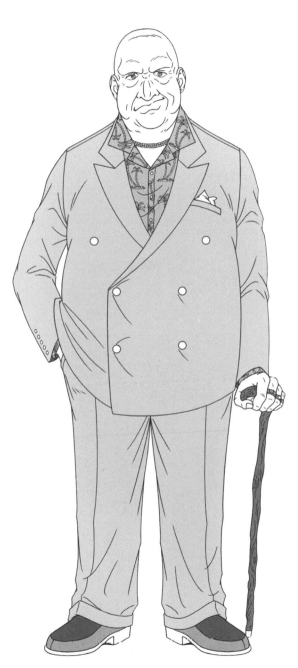

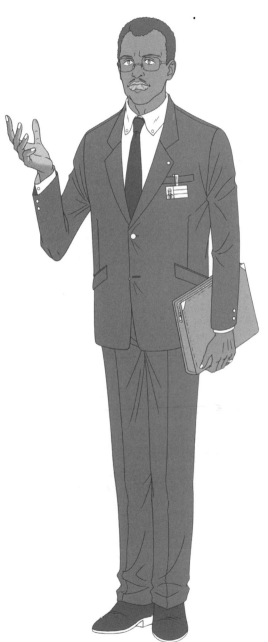

Gangster Boss

I drew him wearing an Hawaiian shirt and no tie. He is slightly heavy in build. Double-breasted suits look good on older, slightly fat men.

Presidential Aide

I drew him with a tie and eyeglasses to make him look intelligent. To make him look even more intelligent, I imagined that he was from an Ivy League school and thus drew him with a button down shirt.

He is wearing a single-breasted suit because that is what the president is wearing. Adding the ID card on his lapel gives him a more realistic feel.

Drawing Distinctions (3)

Whether it be games, anime, or manga, it is important to have characters with different types of motivations to keep the story moving. In its simplest form, this means good and evil characters, but it also extends to characters from different cultures, regions, and religions. They don't have to be good or evil, but they will seem exotic if you give them a different philosophy. Of course, not all of them have to be warriors. You can create a story where the characters from different cultures meet and make new discoveries together.

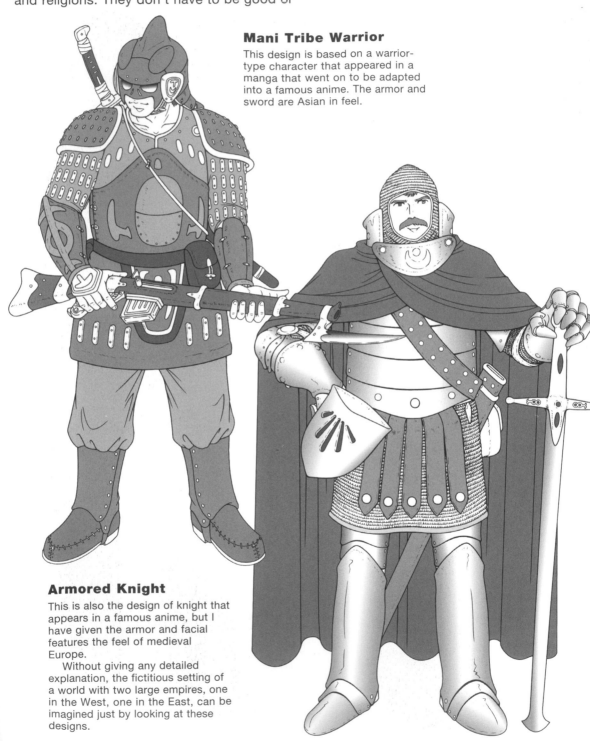

Mani Tribe Warrior

This design is based on a warrior-type character that appeared in a manga that went on to be adapted into a famous anime. The armor and sword are Asian in feel.

Armored Knight

This is also the design of knight that appears in a famous anime, but I have given the armor and facial features the feel of medieval Europe.

Without giving any detailed explanation, the fictitious setting of a world with two large empires, one in the West, one in the East, can be imagined just by looking at these designs.

Drawing Distinctions (4)

When a story is long, it makes sense that the seasons should change. In this case, it is important to make different costume designs for the summer when it is warm, and the winter when it is cold.

Those works that become popular always keep this point in mind, and costumes are designed to fit each scene. The opposite can also be said: those works that elicit a sense of incongruity because characters wear the same clothes in both summer and winter usually do not become very popular.

Winter Version

I drew him with a long-sleeved stadium jacket and a wool cap. There is no reason to think too hard about it. Just start off by thinking about what you wear when you are cold

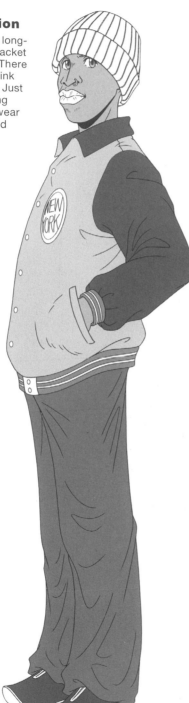

Summer Version

Usually the character would simply wear a t-shirt, but after thinking about it, I put him in a costume that is more keeping with street fashion. To add to the effect of dressing down for the heat, I made his arms thin to contrast them with the thick sleeves in the winter version.

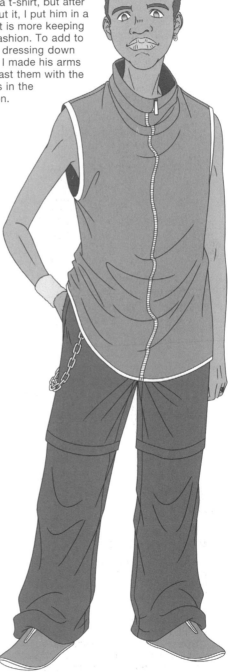

Beast Characters

As the name suggests, beast characters are a combination of animal and human features. To create these characters, you need to know how to draw animals in addition to humans, but in basic terms, they usually have animal heads, feet, and fingers, while their muscular structure is human. Make a rough drawing to get a grasp of the atmosphere of the character and see if the animal parts fit the entire image.

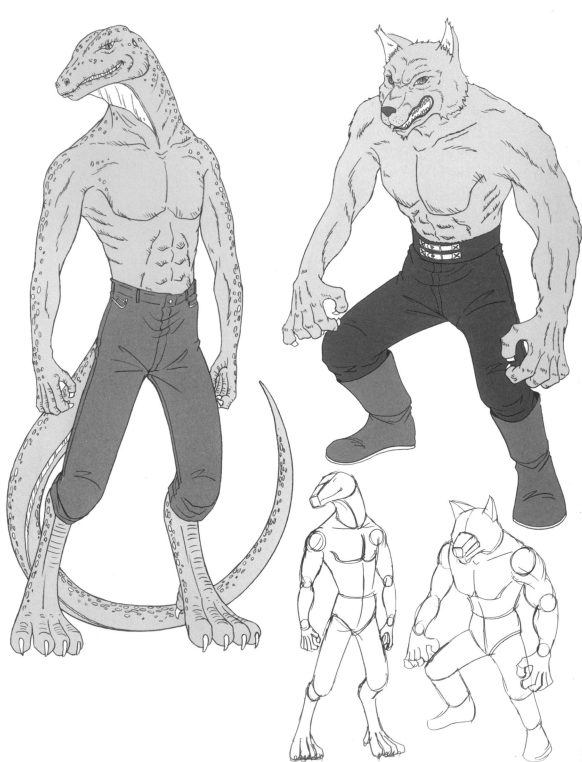

Beast Characters

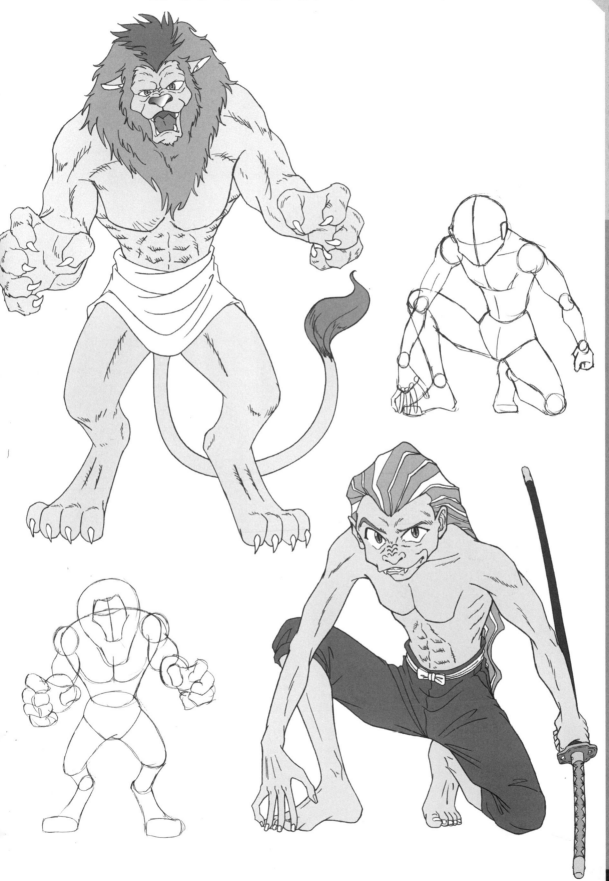

About the Artist
TADASHI OZAWA

To wrap things up, I would like to introduce myself. My parents say that ever since I became aware of my surroundings, I have been drawing something like pictures with crayons or pencils whenever there was paper around me.

When my years as a student were over, I went directly into a line of work where I could earn money by drawing. My first job was at the animation studio Top Craft, which no longer exists. Luckily, I was able to start at a company that created such important work.

After working on anime for a number of years, I took a job at Mad House. This company is also known for a number of famous works, so I am sure you have heard of it.

While working here, my skills improved remarkably. Not only was I in charge of drawing cells for a number of anime works, I also oversaw the work of younger employees. You have probably figured out by now that the contents of this book are an extension of this work and my experience in the industry until now (I currently work on my own).

I seem to have run out of space. In conclusion, I would like to thank all of the staff members for their tireless efforts as we worked on getting this book published, and I would also like to especially thank you, the readers, who purchased the book.